SEVENTIES SPOTTING DAYS AROUND THE SOUTHERN REGION

SEVENTIES SPOTTING DAYS AROUND THE SOUTHERN REGION

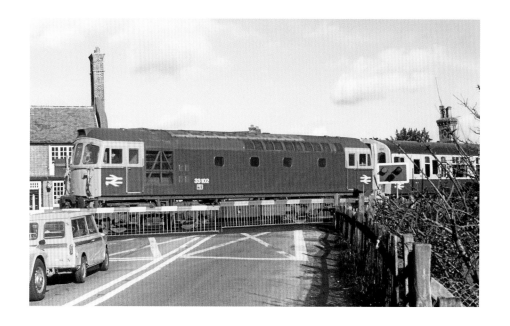

Kevin Derrick

AMBERLEY

This edition first published 2016

Amberley Publishing
The Hill, Stroud
Gloucestershire, GL5 4EP

www.amberley-books.com

Copyright © Kevin Derrick, 2016

The right of Kevin Derrick to be identified as
the Author of this work has been asserted in
accordance with the Copyrights, Designs and
Patents Act 1988.

ISBN 978 1 4456 6085 1 (print)
ISBN 978 1 4456 6086 8 (ebook)

British Library Cataloguing in Publication Data.
A catalogue record for this book is available from
the British Library.

Typesetting by Amberley Publishing.
Printed in the UK.

Contents

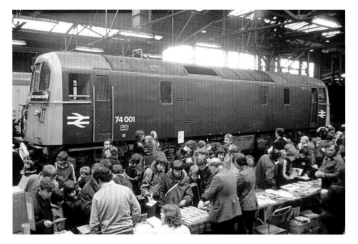

Trade looks brisk inside the workshops at an Eastleigh Open Day on 30 April 1978. In the background No. 74001 is also for sale having been withdrawn on 31 December the previous year. Three months after this shot the locomotive would be hauled off to Bird's Commercial Motors scrapyard at Long Marston and swiftly destroyed. (Nev Sloper)

Introduction

In this volume of the *Seventies Spotting Days* series, we examine how things were on the Southern Region through the decade as well as a few time bites to help us place life as it was over thirty years ago, perhaps helping to jog our ageing memories from the time.

As the decade dawned the region was still home to a wide number of Southern Railway-designed EMUs, also Warships from the Western Region were everyday visitors to Waterloo in charge of expresses from Exeter, in fact variety was everywhere. As the seventies rolled on many of our old favourites disappeared, in their wake Class 50s took over the west of England trains from Waterloo and Paddington, and eventually what seemed to be an endless tide of new 4-CIG deliveries dried up from York.

Throughout the history of our nations railways there have always been dumps and sidings littered with withdrawn locomotives and rolling stock. Perhaps as enthusiasts we take more interest in their contents as we reminisce over the changes taking place. Also for many spotters intent on checking off the numbers of those they have missed in everyday service, the dumps provide a last chance to complete a class. The Southern would not disappoint during the decade on this count.

I often listen to those great songs that stick in your head from the seventies, you know, Abba, Elton John, The Eagles etc., and it always brings a smile to my face. Sometimes I close my eyes, and can even smell things from the era, it was that good! I also remember my John Travolta-style cream flares, side pocket trousers, loafer shoes, *Tiswas* on Saturday morning television, Radio Luxemburg, *Dad's Army*, Chopper bikes, Brut aftershave, 45's and LPs, James Hunt winning the 1976 Formula One season, *Jaws* at the cinema which, along with *Alien*, scared the living daylights out of everyone at the time, Charlie perfume, Dentine bubblegum, the list goes on. Oh, how many of us wish we had a time machine! It would allow us all to go back to those heady days and give us the chance once more to remember how things were as a train spotter in the 1970s. Until someone comes up with such a machine, settle back with perhaps some suitable background music from the time and relive how things were around the Southern Region during the seventies once more.

Kevin Derrick
Boat of Garten

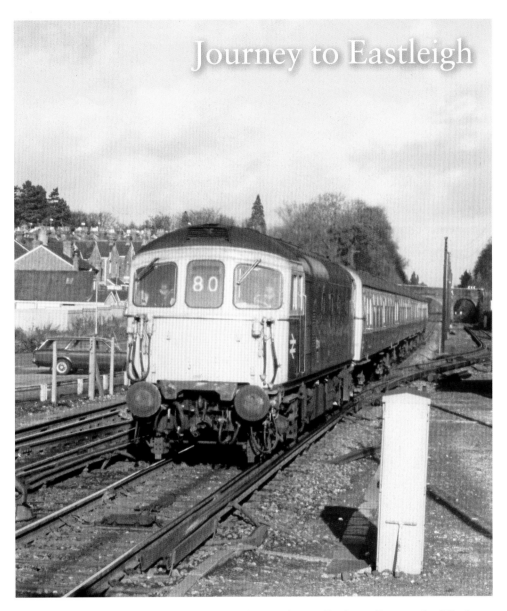

The low sun is in the eyes of our engine crew as they bring in the 10.56 Reading to Portsmouth at Winchester on board No. 33114 on 18 November 1979. Dr. Hook was at number one with 'When Your'e in Love with a Beautiful Woman', and the nation was able to buy the *Times* newspaper again this week after a year's absence due to strike action over the new technology in Fleet Street. We will make the short 7-mile journey on this lovely early winter's day to Eastleigh, which is all downhill from here. (Nev Sloper)

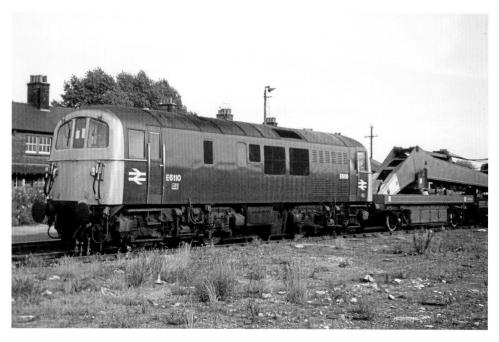

The last of the ten Class 71 locomotives converted at Crewe Works into electro diesels as Class 74 was No. E6110, entering traffic in May 1968. The former No. E5021 is seen at rest on the depot at Eastleigh in 1970 in company with the depot's Cowans Sheldon breakdown crane. (John Ferneyhaugh)

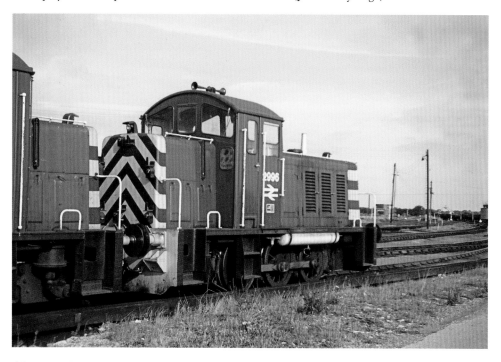

All visits to Eastleigh and Southampton Docks from the early sixties until the mid-seventies would be associated with the Ruston & Hornsby of Lincoln-built Class 07 diesel shunters. On the depot this same day in 1970 was No. 2996, which had first arrived here into traffic on 6 October 1962. (John Ferneyhaugh)

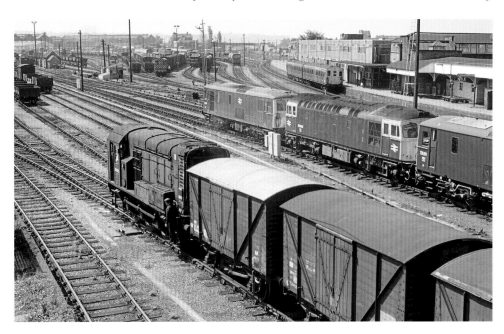

A view from the Bishopstoke Road Bridge in June 1976 shows just how busy this location could be for enthusiasts back then. Beneath us is the gentle rumble from No. 09025 engaged in shunting between the yards, while Nos 73126, 33009 and 73101 are stabled nearby. Another shunter is in the yard and a local service waits to depart with a 2H unit more associated with the Hastings lines. (Arthur Wilson)

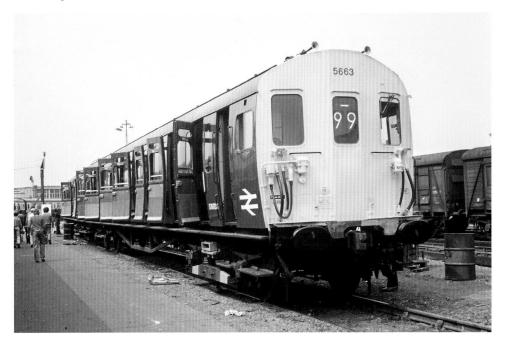

Our party are guided around the works past 2-EPB No. 5663 awaiting a return to working the Windsor lines in July 1977. The doors are open to most likely allow fresh air to reduce the smell of the fumes from the glues used in the carriage works during repairs before the set goes back into service, lest it upset the early morning commuters. (David T Williams)

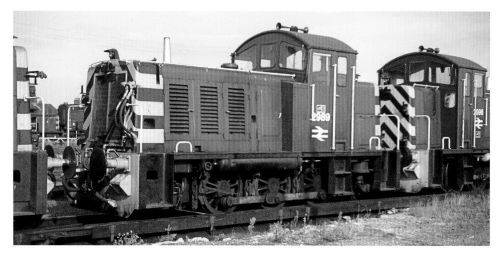

Again in the lines at the depot during 1970 we find No. 2989, this example is fitted with high-level air-braking pipes for working with the EMUs around the works. (John Ferneyhaugh)

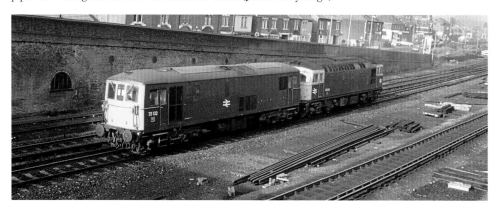

A rapid light engine movement for No. 73132 plus No. 33008, scurrying along the mainline under the road bridge giving access to the depot and the works during 1979. (Dennis Feltham)

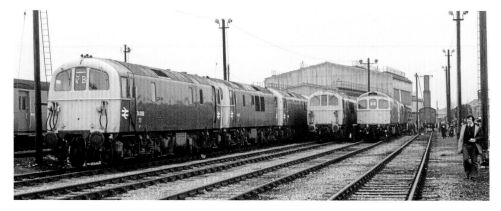

Dumped out the back of the depot during the Open Day on 30 April 1978 were more withdrawn members of the Class 74s, led by No. 74009. The chap on the right is not wearing a high visibility vest but readers may recall the fashion for orange linings to Parka coats at the time. (Nev Sloper)

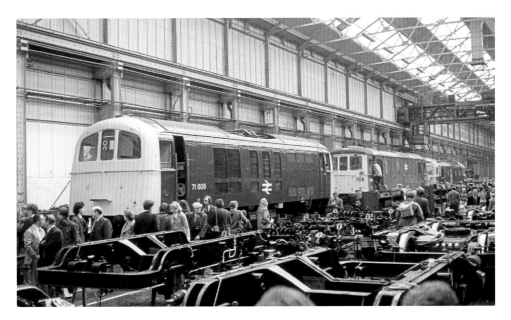

Another works Open Day at Eastleigh on 20 April 1975 with visitors able to climb onto the locomotives as they please, health and safety take careful note! Among those for repairs was No. 71005, this was originally E5020 until 31 October 1968 when it was renumbered to fill in the gap created by the original E5005 which had been converted to E6108. Two others were renumbered during 1968 to fill the other gaps in the series with E5018 becoming E5003 and E5006 being applied to the former E5022. (Strathwood Library Collection)

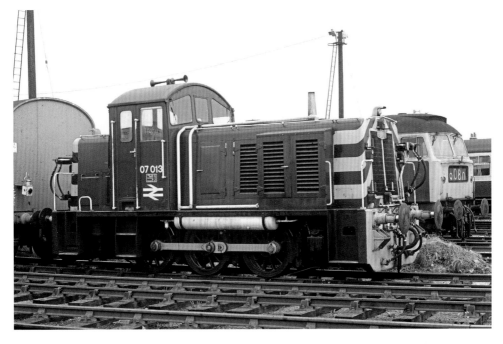

Four of the Class 07 shunters were withdrawn early in May 1973 and never took up their TOPS allocated numbers, leaving No. 07013 as the highest numbered member of the class when seen on 5 May 1974 in company with a Class 47 at the depot. Further work was found for the Lincoln-built locomotive as it was sold for use at the Dow Chemicals plant closer to its birth place at Kings Lynn in November 1978. (Aldo Delicata)

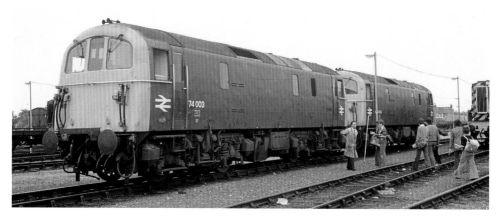

Our guide halts the party in front of Class 74s, Nos 74003 and 74010, in July 1977. (David T. Williams)

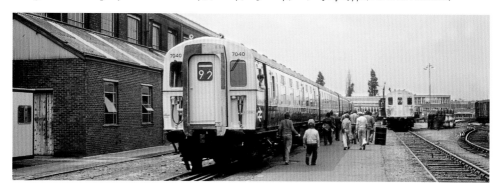

During the same visit 4-BIG No. 7040 is ready to re-enter service any day soon. (David T. Williams)

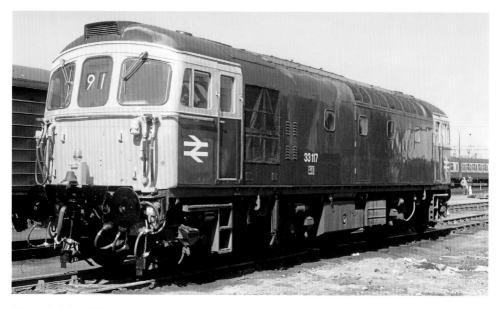

Electric bell fitted No. 33117 is ready for use along the tramway at Weymouth in the yard at Eastleigh during the 1975 Open Day. (Aldo Delicata)

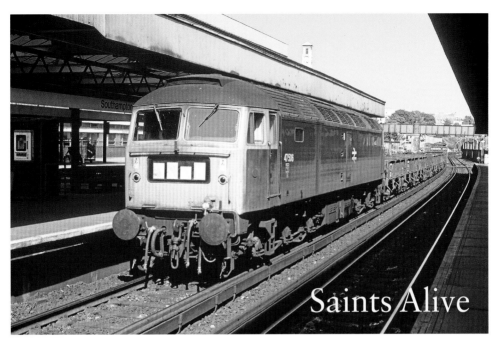

Saints Alive

Displaying a strange toothy grin within the head code arrangement on a permanent way train is No. 47506 in Southampton Central station during that warm summer of 1976. This July saw the first of the five movies in the series about boxer Rocky Balboa, played by Sylvester Stallone, arrive at our cinemas. The story of the unknown dreamer who went on to be heavyweight champion of the world won three Oscars, including best picture. (Arthur Wilson)

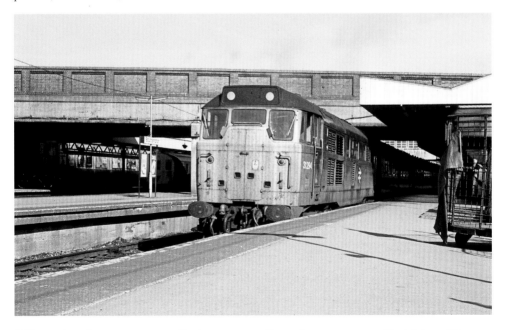

Pulling up into the sun once more at Southampton on 13 September 1977 was a notable sighting of No. 31294 on an excursion. In the newspapers on this day was the death of the leader of the Black Consciousness movement, Steve Biko, in police custody in South Africa. (Nev Sloper)

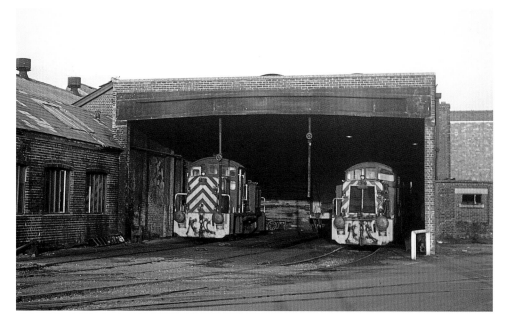

The two differing front ends of Class 07s can be seen with this pair in the docks at Southampton on 18 March 1972. Because of the problems encountered with running hot axle boxes, which the type were prone to when run at speed over longer distance to get them back to works, it was customary to send a fitter out from Eastleigh to attend to any simple maintenance on the locomotives. (Strathwood Library Collection)

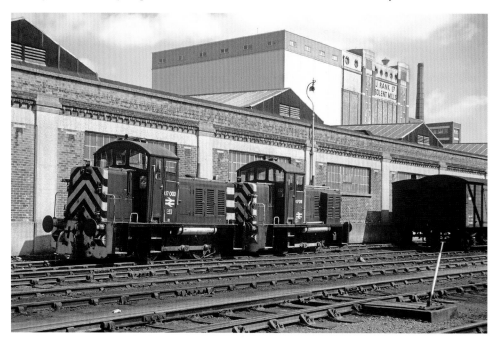

Within the vast docks railway complex built by the Southern Railway and enjoying the sun in their penultimate summer of 1976 are Nos 07002 and 07011. In spite of their reputation for trouble, seven of the class of fourteen engines have seen service now longer in preservation and later industrial use than they did with British Rail during their short careers. (John Ferneyhaugh)

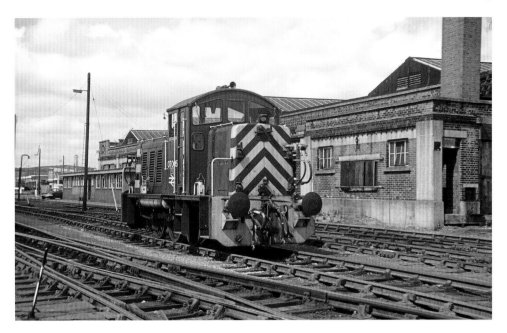

How many spotters walked around the public roads inside the docks to track these elusive shunters down for their ABC's? Otherwise it might take several visits to Eastleigh over a period of time to bag them all, as another No. 07005 was recorded by our intrepid cameraman in Southampton Docks during the summer of 1976. (John Ferneyhaugh)

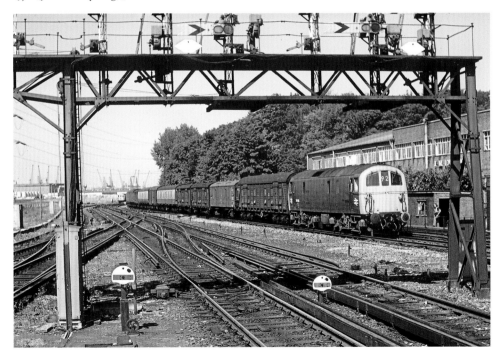

Running into the Central station in June 1976 with an interesting array of parcels vans is No. 74003. The punters' favourite jockey, Lester Piggott, rode to victory with his seventh winner of the Derby at the beginning of the month; his other wins were in 1957, 1960, 1968, 1970 and 1972. (Arthur Wilson)

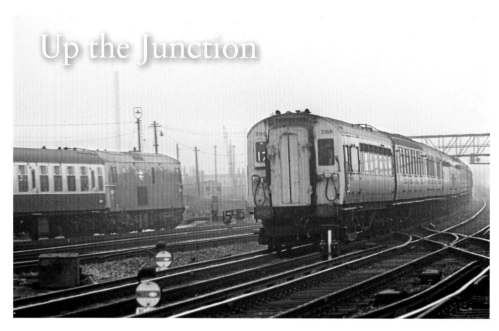

A busy scene close to West London Junction signal box near Clapham Junction on a misty November morning in 1971. A rake of CORs speeds past an electro diesel working stock through the carriage cleaning plant. Within months the Nelsons would be taken off the Portsmouth trains and concentrated onto the south coast routes and the Reading line. (Ian King)

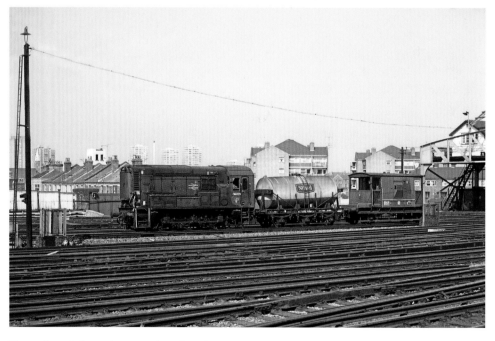

Engaged on a lightweight trip working from the nearby creamery is No. 09023 arriving at Clapham Junction in April 1974. The Southern Region specified a number of former Class 08s to be re-geared with a slightly lower tractive effort, but a more useful top speed of 27.5 mph to help with work such as this trip, in an attempt to keep these workings from disrupting passenger trains on intensively used routes. (Strathwood Library Collection)

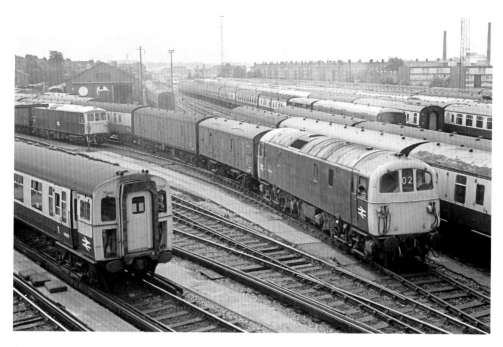

A view from an open window on the enclosed footbridge that linked the Windsor lines with the main station at Clapham Junction on 12 July 1977 finds a packed yard around midday with Nos 73107 and 74004 engaged in shunting stock. Clearance with the Class 73 looks a bit tight! (Colin Whitbread)

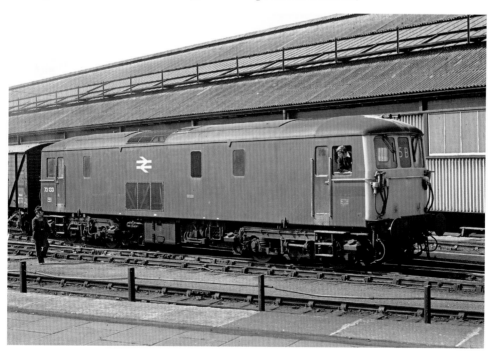

Three years earlier in April 1974 and the Wombles of nearby Wimbledon Common are doing well on television and in the charts as well, meanwhile No. 73133 busies itself with tidying the yard at Clapham Junction. (Strathwood Library Collection)

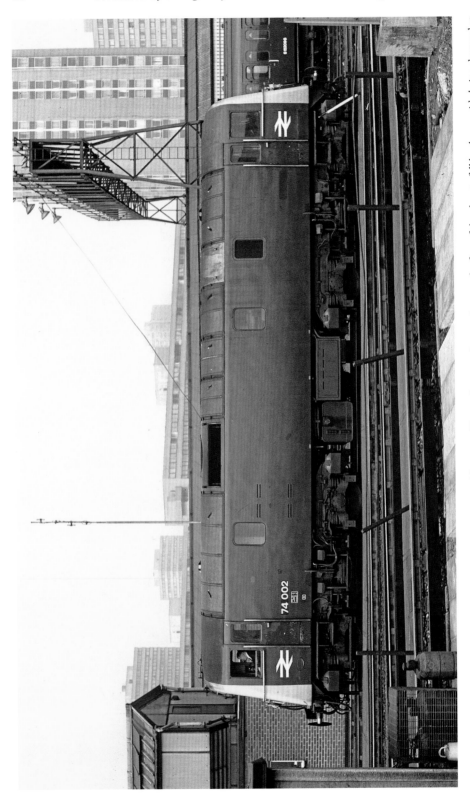

Also Wombling about in the yard on the same day in April 1974 was No.74002. This unfortunate locomotive was the first of the class to fall by the wayside being dumped at Eastleigh by December 1976 as a source of spares to keep other classmates in service, all very acceptable to Uncle Bulgaria perhaps? (Strathwood Library Collection)

Not all of the Bulleid designed 2-HAL units went straight to the scrapyards of south Wales, Derbyshire and Yorkshire in the early seventies. Two units were made up from converted motor coaches into Nos 022 and 023 as stores units to move spares around the Southern's multitude of depots. The first of this pair, No. 022, makes its way along the Windsor lines to either Wimbledon via East Putney or perhaps to Strawberry Hill in April 1974. (Strathwood Library Collection)

Also on the Windsor side at Clapham Junction is Class 42 Warship D809 *Champion* on 2 October 1971, where the crew are changing ends to take the locomotive via the West London Line to Old Oak Common, who condemned it the next day. It remained at 81A until June 1972, when it was towed to Laira as a source of spares, before a trip to Swindon Works the following month. By early October 1972 this old favourite had been broken up. (Frank Hornby)

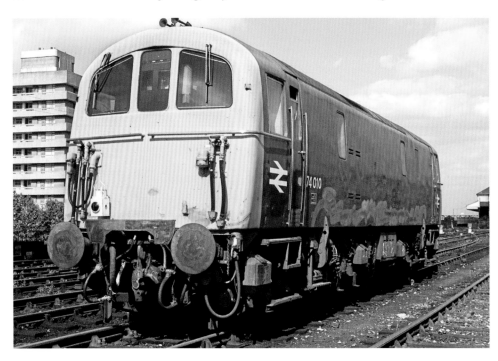

Stabled on the non-electrified sidings at Clapham Junction on 17 August 1978 was No. 74010 which was on its way to Derby for use as a generator, where it arrived the next day. (Colin Whitbread)

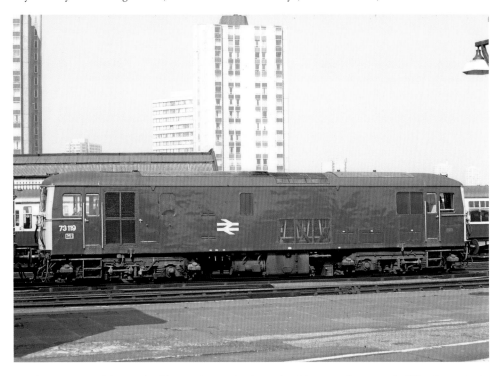

Much more successful were the Class 73 electro diesels, such as No. 73119 departing for Waterloo with the stock for a boat train in April 1974. (Strathwood Library Collection)

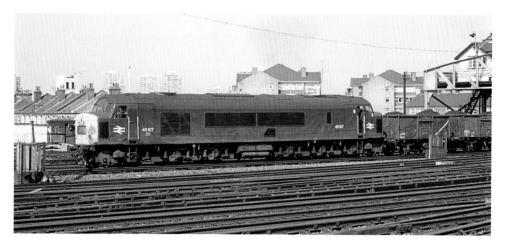

Spotters at Clapham Junction in April 1974 would perhaps enjoy the passage of several Peaks during a day on the station here, making their way back to the London Midland Region via New Kew Junction, such as No. 45107 on a loaded coal train. (Strathwood Library Collection)

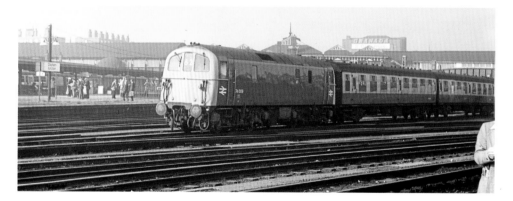

From a vantage point on the Windsor side we see No. 74009 waiting to take stock to Waterloo on the morning of 18 September 1976. (Ian James)

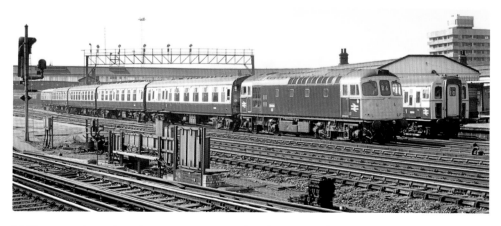

Making up another train in the extensive carriage sidings here during April 1974 is the former D6542, which had recently been renumbered as No. 33024 during February. (Strathwood Library Collection)

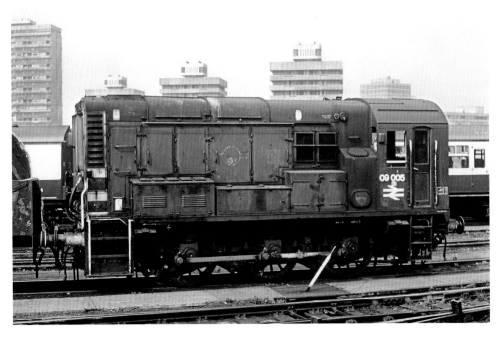

Hard to tell what the real colour is under the grime on the former D3669 from Selhurst, renumbered now as No. 09005 in April 1974. The painters at Selhurst must have been too busy at the time, as the locomotive strangely carries both the old totem and a set of Inter City arrows. (Strathwood Library Collection)

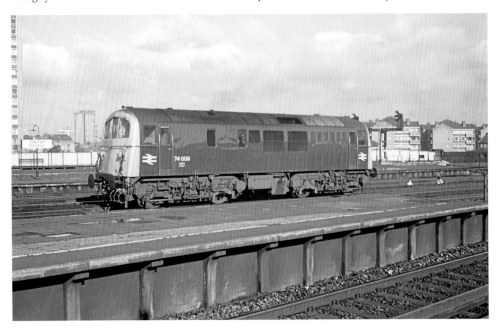

After conversion at Crewe into Class 74s the ten engines were sent to Stewarts Lane for further testing and to make crews familiar with the rebuilt locomotives, this one going into traffic on 28 March 1968 as E6109. The new number, 74009, was applied in January 1974. The paintwork on the body sides gives a reasonable impression when seen on 18 October 1974. A service life of just nine years as a Class 74 followed seven years as a straight electric locomotive numbered as E5017. (Frank Hornby)

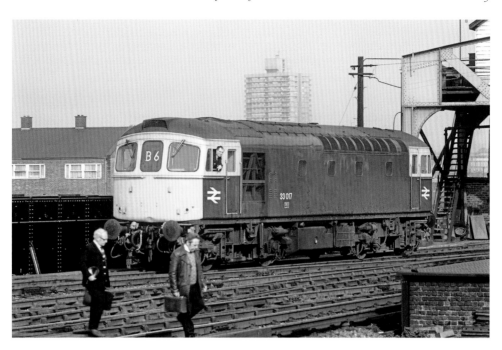

This pairing are booking off while the crew of No. 33017 watch out on 28 February 1975, across the other side of the city at Moorgate, twenty-nine passengers and the driver of a Northern Line tube train had died that morning in an unexplained tragedy where the train ran through the station into the buffer stops at 30 mph. (Strathwood Library Collection)

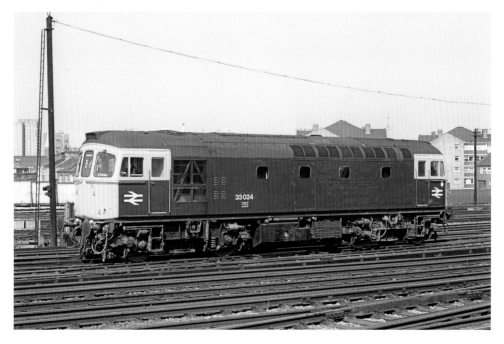

Still engaged in shunting the yard in April 1974 was No. 33024. This engine would also suffer misfortune when it ran into the rear of a Portsmouth train at Cardiff General whilst working its own train to Manchester in January 1986. (Strathwood Library Collection)

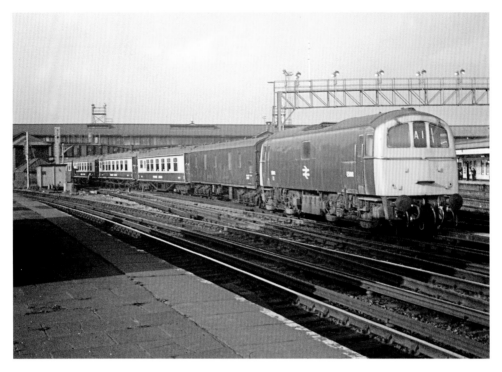

Unusual to find the Pullman stock of the Golden Arrow being worked by Class 71 E5011 at Clapham Junction in early 1972. (Strathwood Library Collection)

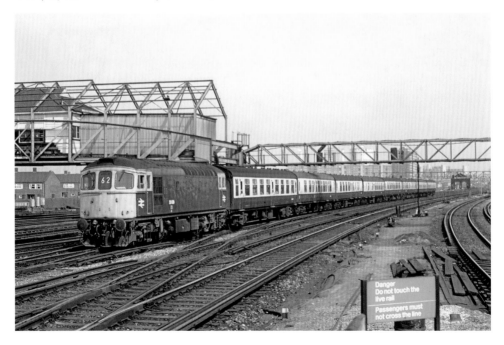

Engaged on a Salisbury semi-fast service during early spring 1974 we find Class 33 No. 33029 still fitted with a three-piece snow plough from the winter, not that it would be needed in the suburban area. (Strathwood Library Collection)

Along the Coast

It is the last day of the Brighton Belle in revenue service and 5-BEL No. 3052 leads another parked up at Brighton, alongside are sets of 4-CORs – their days were also numbered by 30 April 1972. (John Green)

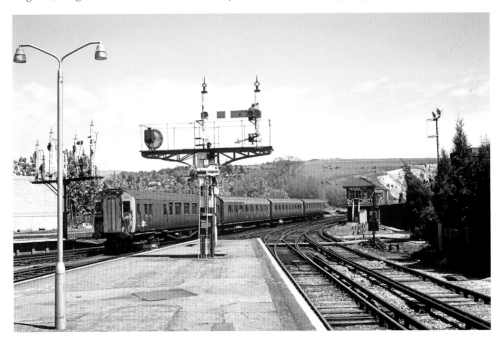

Workings along the south coastal route through Sussex would keep several of the remaining 4-CORs active during their last summer, such as No. 3151 recorded at Lewes, while the splendid semaphore signal gantries survived in 1972. (Michelle Howe)

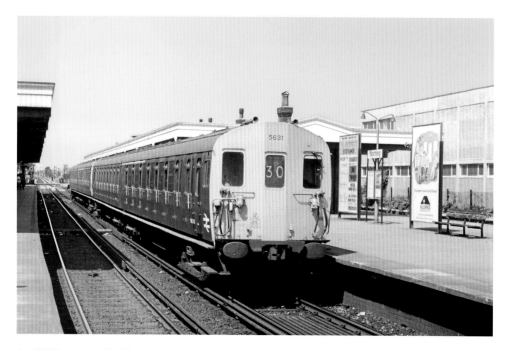

A 2-HAP pairing led by No. 5631 has pulled up at Worthing on 30 June 1973 whilst working on the Brighton to Portsmouth line. This same year brought the camp humour of *Are You Being Served* to our television screens, with John Inman who declared 'I'm free' whenever a customer needed attention, the catchphrase stuck for a long time. (John Dawson)

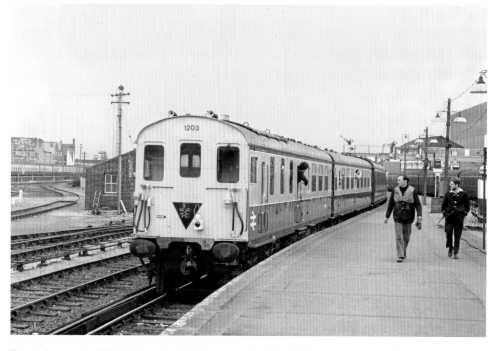

By 10 May 1979 the BBC had another hit sitcom on its hands with *To the Manor Born*. An ex-works Tadpole No. 1203 in a mixed livery was caught by our cameraman pulling away from Eastbourne on this day. (Ian James)

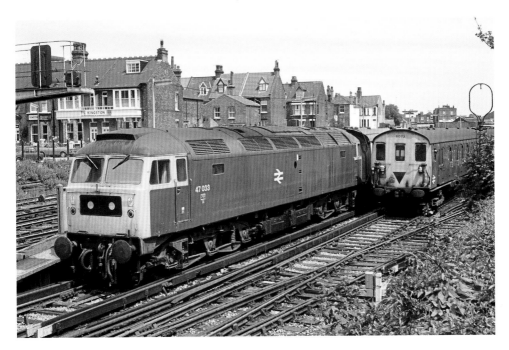

A Laira-based No. 47033 has charge of the 08.45 Oxford to Margate on arrival at the seaside resort on 27 June 1977. One of the 2-HAPs, No. 6073 built for the Kent coast electrification of the early sixties, waits alongside. Earlier in the month street parties had been held to celebrate the Queen's Silver Jubilee all across the country, we were all in a party mood! (Colin Whitbread)

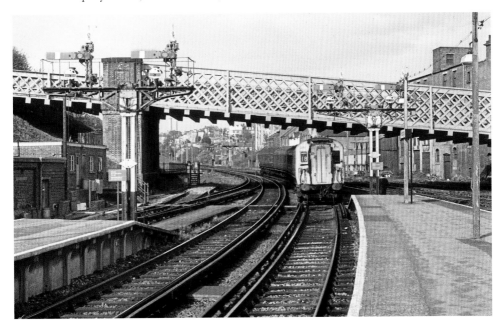

Southern Railway semaphores greet the arrival of 4-COR No. 3151 as it works an Ore to Brighton service into Hastings on 6 May 1972. Later this Saturday afternoon at Wembley the Centenary FA Cup Final was taking place between Leeds United and Arsenal. Not a classic by any means, which was decided by an Alan Clarke goal sending many Yorkshire men home that evening happy with the result. (John Dawson)

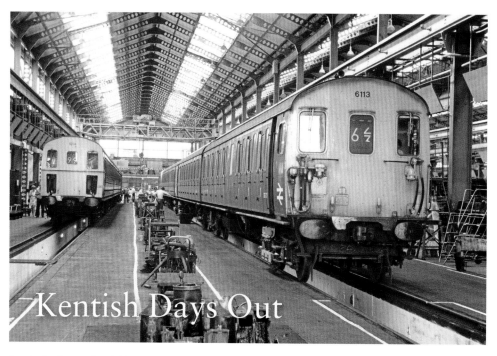

Kentish Days Out

Inside the former South East and Chatham Railway's works at Chart Leacon on 19 August 1978 a 3D East Sussex set undergoes repairs alongside a rake of 2-HAPs. (Ian James)

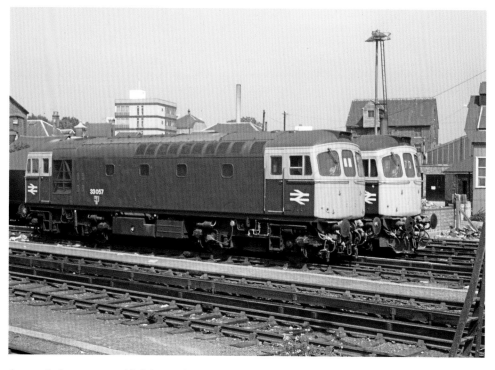

Among the locomotives stabled close to Ashford station two years previously, on 21 August 1976, was No. 33057 which had been allocated to Hither Green ever since entering service almost fifteen years earlier. (Nev Sloper)

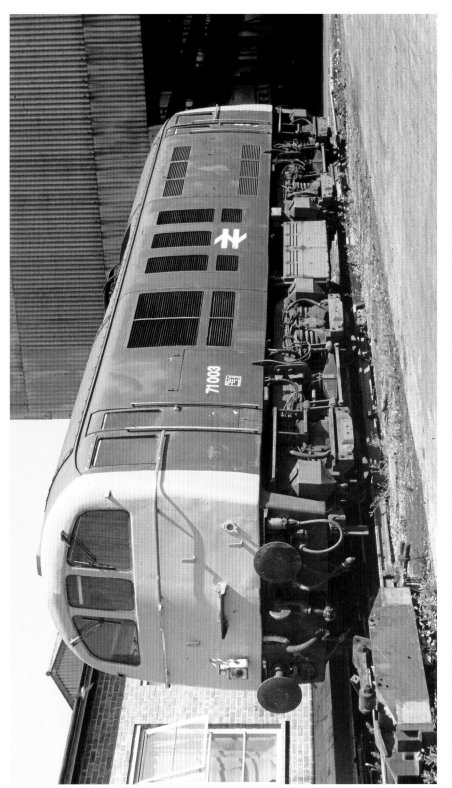

Placed into store at Ashford from April of 1977 was Class 71 No. 71003, caught on camera on 19 August 1977. Just after Christmas that year it was moved to Stewarts Lane for another three years and then on to Doncaster Works who had built the locomotive in early 1960. However, it joined several classmates at the Yorkshire locomotive works for breaking up in January 1980. (Ian James)

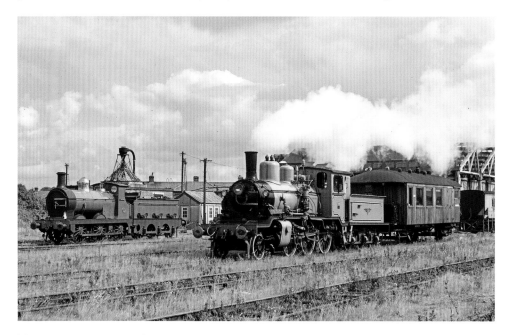

The former steam shed at Ashford, although overgrown with weeds, was host to a number of preserved locomotives as the Ashford Steam Centre in the early seventies. It even became a sanctuary for several coaches from the region's 4-DD double-deck units for a while. When visited on 10 September 1972 our cameraman found former SNCF Mogul 230D 116 in steam alongside a previous local resident SECR Class 01 No. 31065 now returned to its original guise as No. 65. (Aldo Delicata)

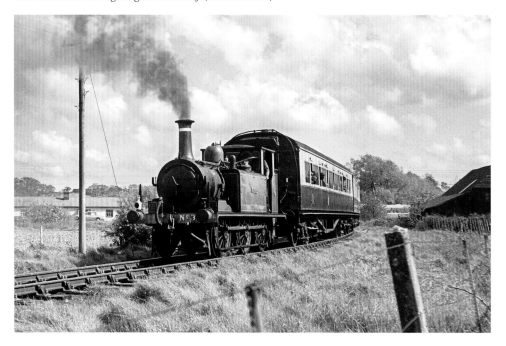

Thriving today is the Kent and East Sussex Railway, who back in 1974 were running services behind Terrier 0-6-0T 3 Bodiam which had been numbered 32670 by British Railways.
(Colin Rodgers/Strathwood Library Collection)

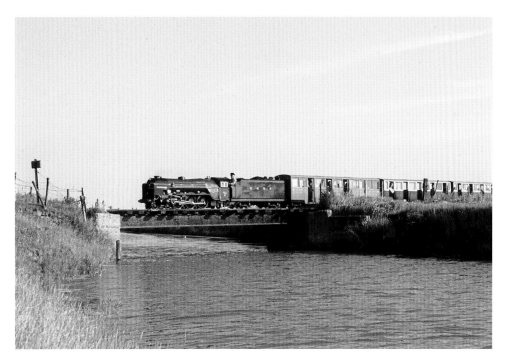

For enthusiasts and families having a day out and looking for a whiff of steam the Romney, Hythe and Dymchurch Railway would always provide a fun day. The Davey Paxman-built Pacific, No. 2 *Northern Chief*, from 1925 is seen near Hythe on 23 June 1973. (Peter Coton)

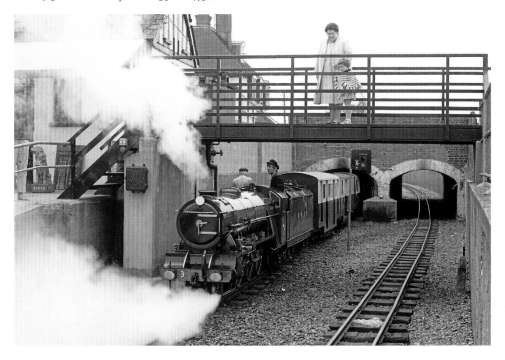

A young lady watches with some apprehension as No. 3 *Southern Maid* prepares its train on 3 July 1971. (Gordon Brown)

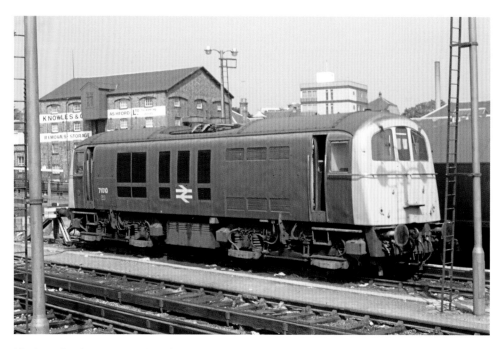

Not long after this view was taken of No. 71010 at Ashford on 21 August 1976 the Class 71 was placed into store here. Lingering around for a year in open storage, it was officially withdrawn in November 1977, later joining others parked at Stewarts Lane and finally being dragged to Doncaster Works who wasted no time in cutting it up in August 1979, a few days after it arrived in their yard. (Nev Sloper)

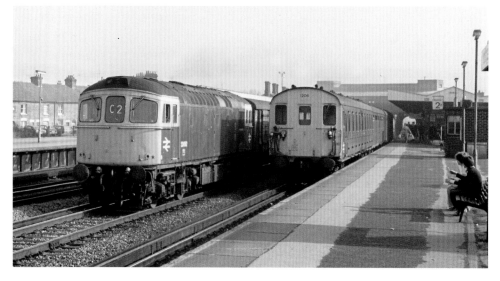

Two spotters record No. 33062 running through on the fast lines, while Tadpole No. 1206 is halted at platform 2 at Tonbridge on 29 October 1978. One of the most memorable films of 1978 was *Midnight Express*, which was based on a true story. It is a harrowing tale of a naïve American tourist imprisoned in a Turkish prison after being caught smuggling a large amount of hashish out of the country. The conditions are intolerable with violence, filth, rape and inedible food but Billy Hayes (Brad Davis) does manage to gain a few confidantes behind bars. When he can't take any more, he decides to take the 'midnight express' – prison slang for escape. The film also stars John Hurt as an intelligent, drug-addicted Englishman a long way from Tonbridge. (Ian James)

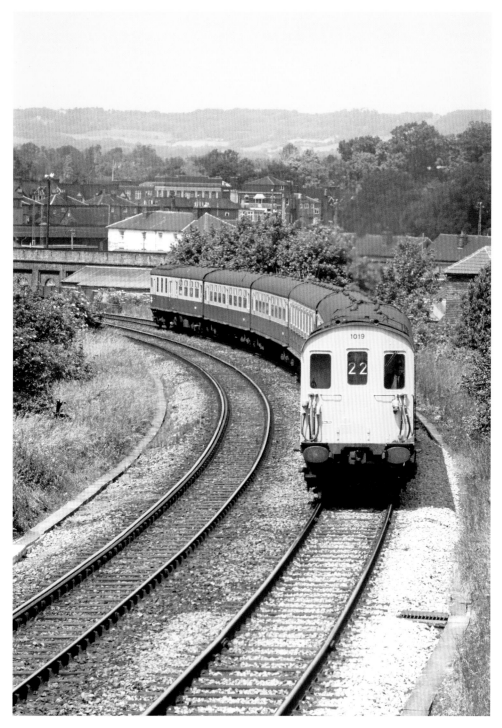

You can almost hear the noise this Hastings unit No. 1019 would be making as it powers around the curves at Tonbridge on 7 July 1977. By this time these units had been in command of these services for twenty years. They would manage another nine years on the Charing Cross and Cannon Street routes to Hastings, with the final runs in May 1986. (Ian James)

Two shots of Hastings set No. 1031 at Tonbridge taken on 7 July 1978. Sadly this was the day after eleven people died and seventeen were injured in a blaze on the Penzance to Paddington sleeper service.

It was thought that the fire was started by a discarded cigarette or an electrical fault near one of the top bunks in a second class compartment. An attendant pulled the emergency cord on the 21.30 from Penzance and the train stopped, half a mile from its next scheduled halt at Taunton, at 02.48. Although fire-fighters arrived within four minutes, their efforts were hampered by internal and external locked doors.

The regulations governing sleeping cars on Britain's railways would be influenced from this tragedy in the following years. It was the worst accident on Britain's railways since November 1967, when forty-nine people died in a derailment at Hither Green, involving a train made up of two of these Hastings sets. (Both photographs Ian James)

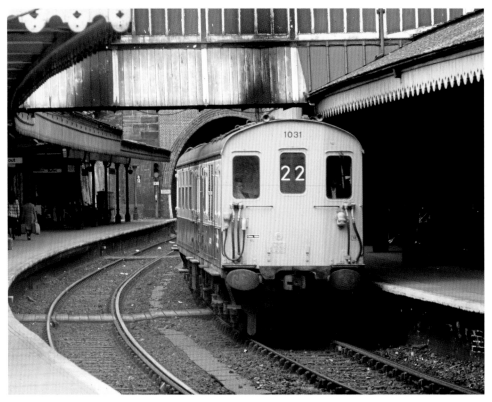

Central Section

Allocated to D05 Crewe when seen at Guildford on 1 August 1970 was Class 47 D1544, this locomotive was repainted into blue the following February and became No. 47015 when the TOPS number was applied in March 1974. (Frank Hornby)

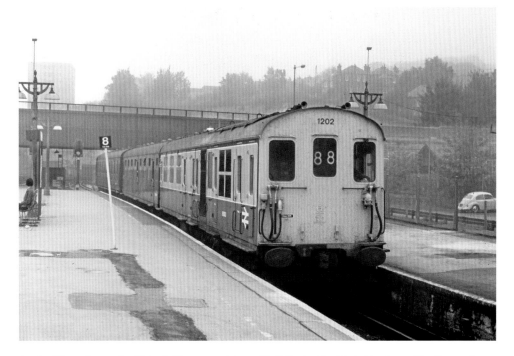

A mixed livery for another Tadpole No. 1202 arriving at Guildford with a Tonbridge line to Reading service on 14 October 1976. When steam finished throughout the Southern Region on 9 July 1967, the shed here coded 70C, closed completely. (Ian James)

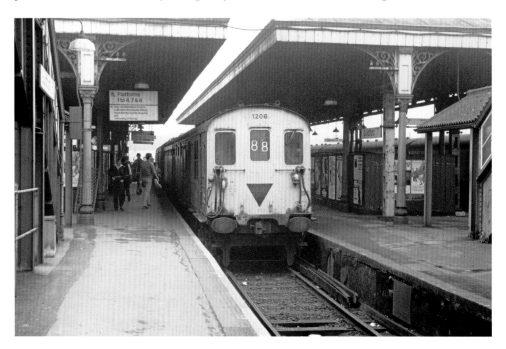

Two years later and this Tadpole unit still retains all of its coaches in an overall blue livery on 14 October 1978, again in the double-sided platform road at Guildford while working another Tonbridge to Reading cross country service for which these units took over from Maunsell's Moguls who reigned on the route in steam days. (Ian James)

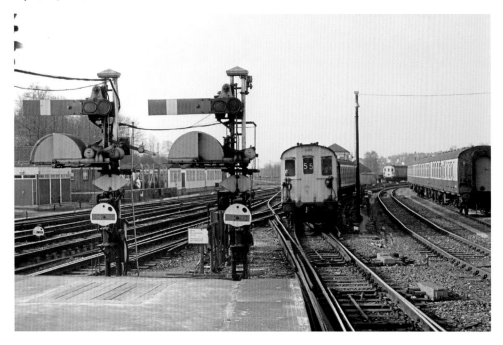

Redhill was another location that gave up its shed as steam disappeared from the region in the mid-sixties. Another Tadpole No. 1205 draws in on its way from Reading to Tonbridge on 8 April 1978 past some delightful semaphores as a further reminder from earlier days. (Ian James)

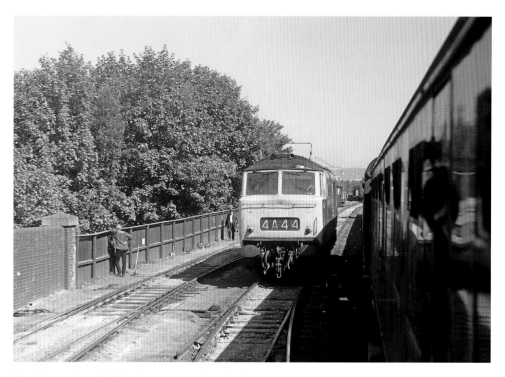

Seen from on board a Tadpole unit we catch sight of a visiting Class 35 Hymek D7017 in a pleasant surprise, while its crew await our passage through Redhill on 4 September 1973. (Ian James)

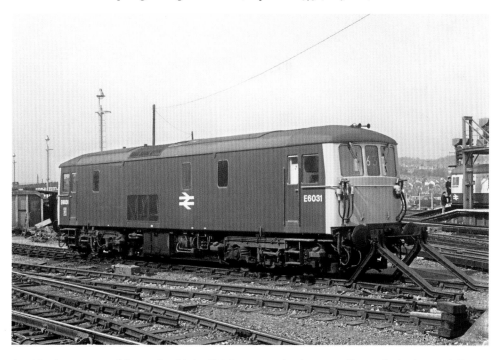

Awaiting its next turn of duty and stabled at Brighton on 28 April 1972 was E6031 which, along with E6026, would be the last of their class to be renumbered into TOPS during April 1974. (Strathwood Library Collection)

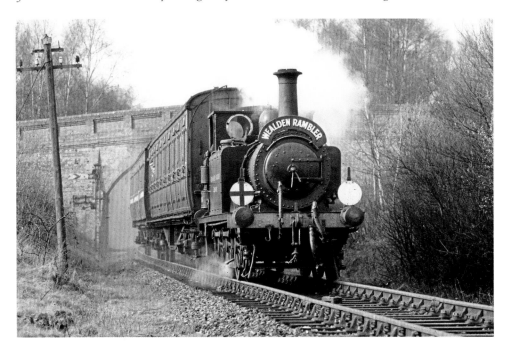

Whilst in the Central Section we must make a brief call into the Bluebell Railway who had far fewer locomotives to run their service trains on 31 March 1970 than any visitor to the line would be able to see today. The former British Railways Terrier No. 32636 had been restored and keeps steam alive in Sussex. (Aldo Delicata)

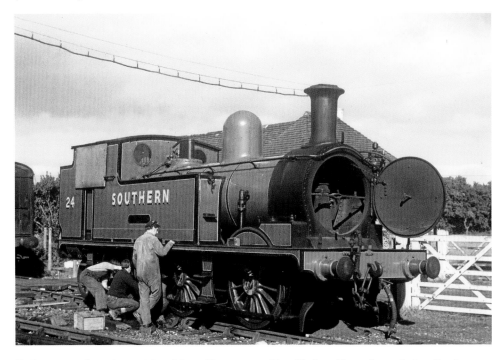

Enthusiasts work on the surviving Adams Class 02 0-4-4T 24 Chale at Haven Street during October 1971, almost five years after steam had finished on the Isle of Wight. (Strathwood Library Collection)

The Isle of Wight was to become a safe haven for the sole surviving Hunslet-built Class 05 which had entered service as No. 11140 in May 1956 based at Parkeston Quay, later, in January 1959, it took on the number D2554. Now as No. 05001 and seen inside the shed at Ryde on 13 September 1977, it had another identity to take on still, as No. 97803 in January 1981 when it was taken into Departmental Stock. (Nev Sloper)

Almost treated as a working museum on the Isle of Wight by June 1976, we find one of the second-hand 1927-built ex-London Transport tube trains, reformed to become a 4-VEC unit numbered as 045. Here running as a three-car unit under the Esplanade at Ryde. (Arthur Wilson)

Into Dorset

The drivers of a Series One Jaguar XJ6 and a Mini Clubman Estate patiently await the passage of No. 33102 along with 4-TC No. 408 on 19 February 1977 at Brockenhurst. A popular single was from David Soul who had made his name in *Starsky and Hutch* on television in the seventies and was now having singing success with 'Don't Give up on us Baby', and maybe playing on these drivers' car radios at the time. (Colin Whitbread)

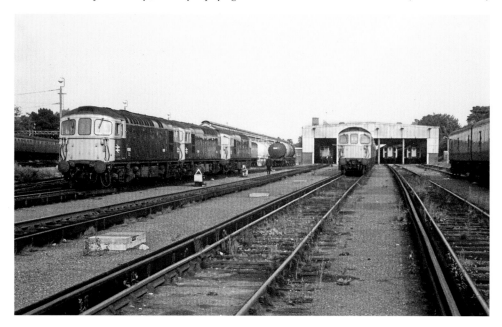

A wide line up of Class 33/1s at Branksome depot in Bournemouth during a visit in 1972, on the right is stabled one of the de-icing units converted from 2-HAL units, just in case of winter ice problems around the New Forest area. (Strathwood Library Collection)

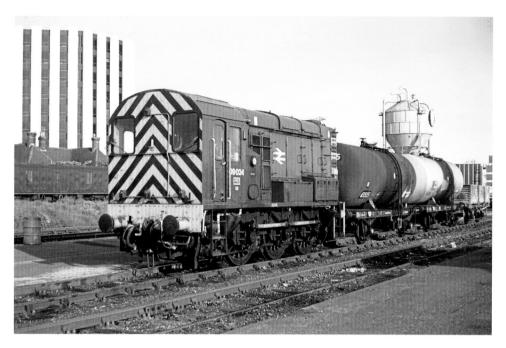

In between shunting duties at Poole station on 16 May 1978 was another of the region's Class 09 shunters No. 09024. The duties for this shunter at the time would include dealing with Hamworthy Freight Depot during weekdays, but it would return to Bournemouth depot every Friday afternoon for servicing over the weekends. (Strathwood Library Collection)

Seen from the hillside at Corfe Castle in 1971 during the last year of service on the branch from Wareham to Swanage, is a well-kept 3H Hampshire unit which kept things going until closure on 3 January 1972. Today of course things are prospering and the branch is alive once again throughout the year. (John Samsom)

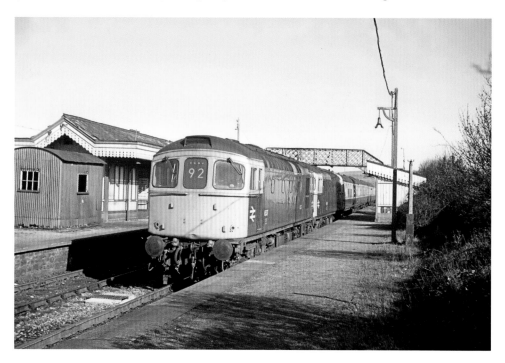

Double heading through Upwey and Broadway station on 28 March 1972 are Class 33s D6537 and D6531. Two days before this shot was taken the last trolleybus system in the United Kingdom closed in Bradford having served the Yorkshire city for more than sixty years. (Strathwood Library Collection)

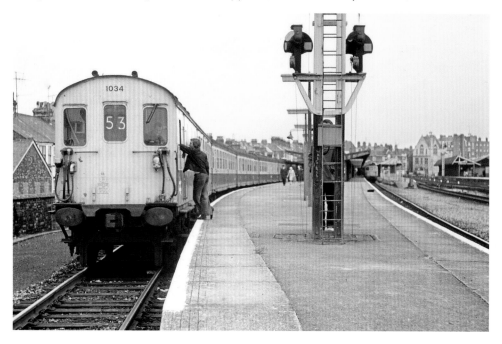

The use of Hasting sets for excursion traffic was popular in the seventies; one such working has brought No. 1034 to Weymouth on 19 July 1975. These versatile units would venture to locations as far afield as Plymouth, Norwich and Spalding on this type of work. (Ian James)

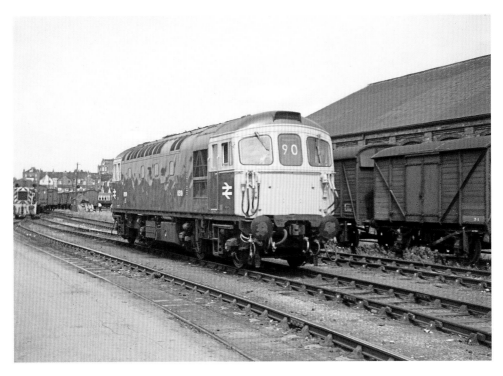

Awaiting the Class 03 to move onto the boat train that Class 33 No. 6519 has brought to Weymouth in 1971; the shunter will take the train along the quayside. (John Ferneyhaugh)

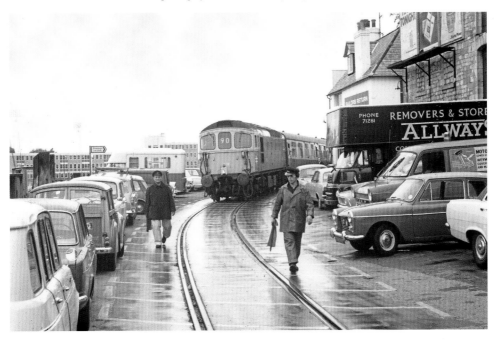

The two pilots are dressed for the rain as they escort Class 33 No. 6532 along the quayside to Weymouth on 6 August 1973. A study of the parked vehicles suggests almost all are from the sixties in the days when most people kept their cars for much longer than is the custom today. (John Dawson)

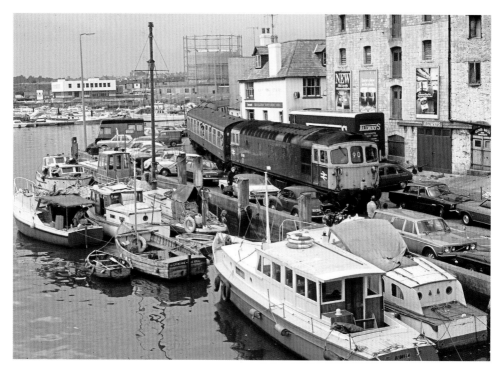

Fitted with a warning bell is No. 33118 as it winds the 09.36 Waterloo to Weymouth Quay over the last mile of its journey on Sunday 7 August 1977. (Colin Whitbread)

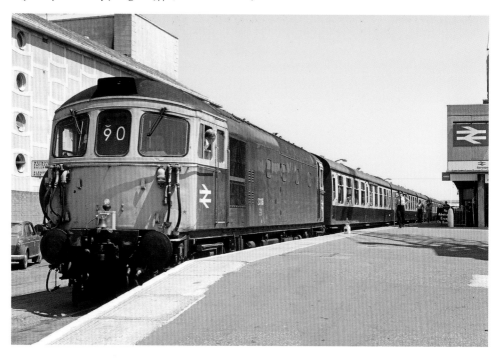

Also fitted with a bell we find No. 33116 outside the passenger terminal in July 1976, the destination boards are still in use on the sides of the coaches to assist the passengers. (Arthur Wilson)

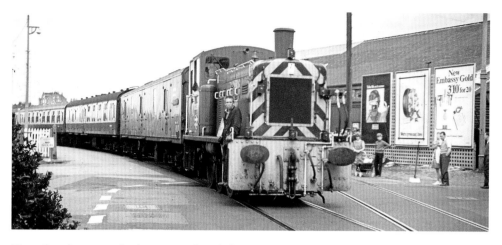

The pilot elects to ride shotgun on board Class 03 D2399 along Weymouth Quay during 1971. (John Ferneyhaugh)

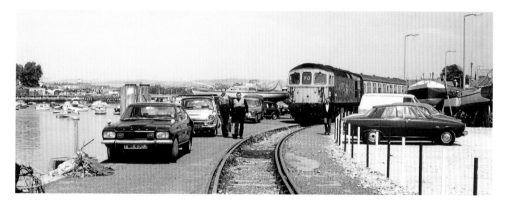

Clearance on the curves could be tight with parked cars as No. 33105 progresses on 30 July 1977. (Roger Griffiths)

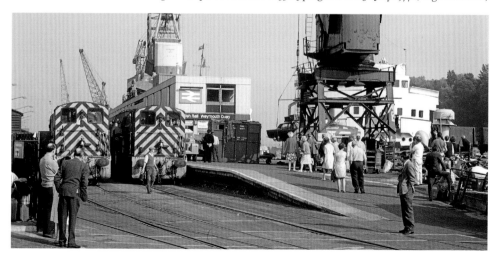

A pair of Class 03s are at the terminal in September 1971 as a Ford Zephyr is unloaded in the background off the moored ferry. (Gordon Brown)

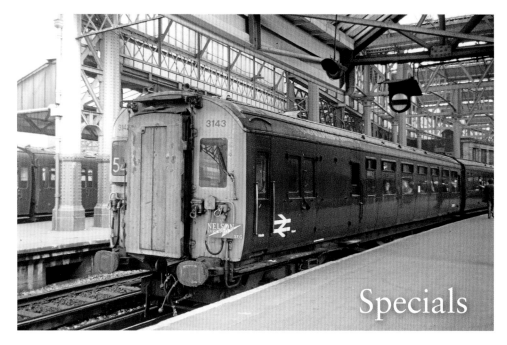

Specials

When the Southern Electric Group organised this tour headed by Nos 3143 and 3102 from Waterloo on 1 October 1972 it was intended to be the last run of the 4-CORs, but there was to be a further one two months after they had been withdrawn, which ran on 9 December 1972. (Strathwood Library Collection)

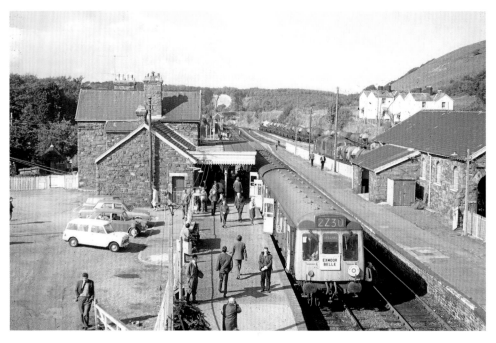

On the former Withered Arm of the Southern at Torrington, and a chance for the passengers on board this LCGB/RCTS-arranged Exmoor Belle in 1970 to stretch their legs. In the bay a Class 22 has the task of dealing with milk tanks. One of the Western Region's BRCW, built three-car DMUs has been selected for use on the tour. (Strathwood Library Collection)

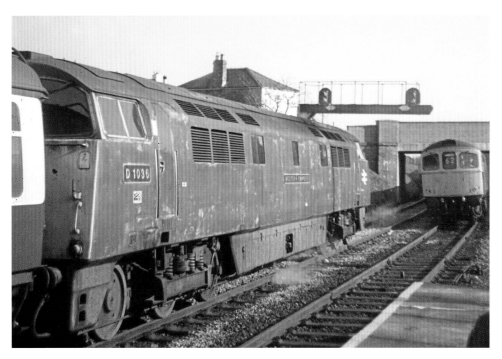

Another Western Region influence in this view as we believe that D1036 *Western Emperor* has possibly been diverted, rather than working an excursion here at Honiton, and is about to pass Class 33 No. 33060 coming the other way along the former LSWR main line to Exeter. (Nev Sloper)

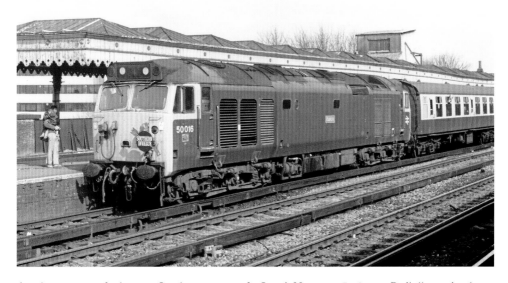

Another incursion further into Southern territory for Laira's No. 50016 *Barham* at Redhill on 7 April 1979 with the R.P.P.R.-organised Southern Invader tour that employed the Hoover throughout on a real adventure around the region which started from Paddington. (Ian James)

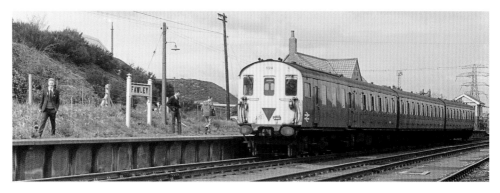

On 22 March 1975 The Branch Line Society conducted a more modest tour which brought a Thumper onto the Fawley branch with their Hampshire Rail Tour. (Ian James)

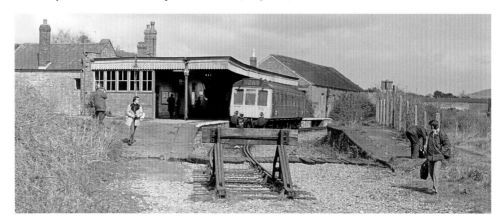

Enthusiasts gather to record the end of the Bridport branch with W55032 in March 1975. (Ian James)

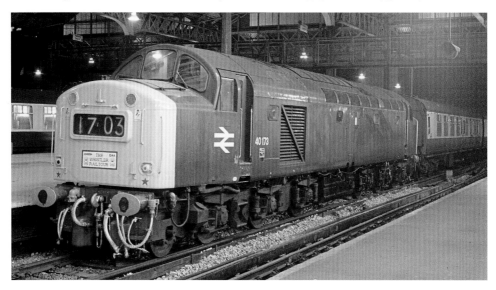

Arrival back at Victoria was after dark for No. 40173 on The Whistler Rail Tour on 11 February 1978. (Colin Whitbread)

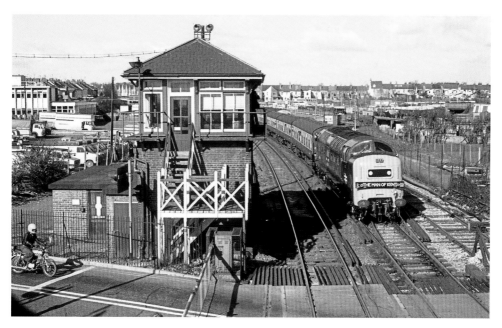

English Electric super power from Deltic No. 55007 *Pinza* as it passes Gillingham with the Man of Kent on 26 March 1978. This tour started from Victoria with a trip out to Dover and back to London Bridge before a run to Bognor and Littlehampton to bring the participants back to Victoria over ten hours later. (Colin Whitbread)

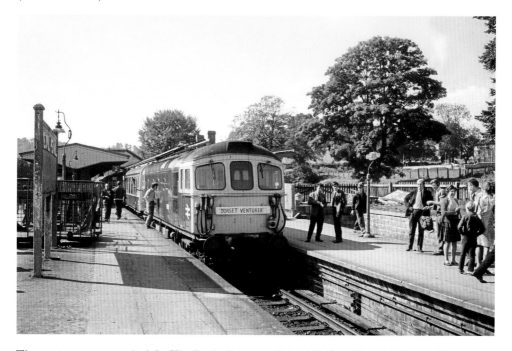

The motive power supplied for The Poole Grammar School Railway Society's Dorset Venturer on 18 September 1971 was Class 33/1 No. 6528 with 4-TC 403 for the day. The stop here at Yeovil Pen Mill allowed a change of direction with the Crompton using its push and pull capability to the full and gave our cameraman a chance to record the event. (John Samsom)

The chance to compose a shot across the still waters at Rockley Sands of No. 47539 in charge of the Royal Train on 23 March 1979 was too good to miss. Just a few days later and we were all wondering where was Three Mile Island in America, as it scared the world with a nuclear leak from the Pennsylvania power station. (John Samsom)

Another Royal Train duty for Class 31s Nos 5809 and 5890 at Eastbourne, thought to be the first time any of the class had visited this south coast resort on 28 November 1973. In the news that week was the death of modern Israel's founding father David Ben-Gurion and its first prime minister, who died aged 87. (Ian James)

Another notable death brought about this use of the Royal Train for the funeral of Lord Louis Mountbatten on 5 September 1979. In charge of the ECS working into Waterloo was No. 73142. Thousands lined the route of the procession and the memorial service at Westminster Abbey was attended by royalty, leaders and politicians from all over the world. (Colin Whitbread)

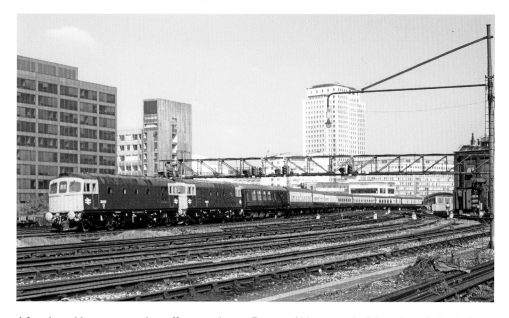

After the public ceremony the coffin was taken to Romsey Abbey near the Mountbatten's family home in Hampshire and buried at a private service, with the train being headed by a specially prepared pairing of Class 33s from Stewarts Lane for the journey from Waterloo to Romsey behind Nos 33027 and 33056. (Colin Whitbread)

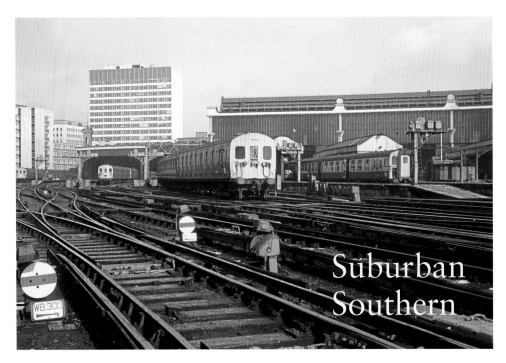

Suburban Southern

A Hounslow loop service departs from Waterloo with 4-SUB No. 4658 on 7 March 1970. A scene that would change massively in the following decades, but just now Lee Marvin was top of the charts with 'Wand'rin' Star' – long before the arrival of the Eurostars. (John Sansom)

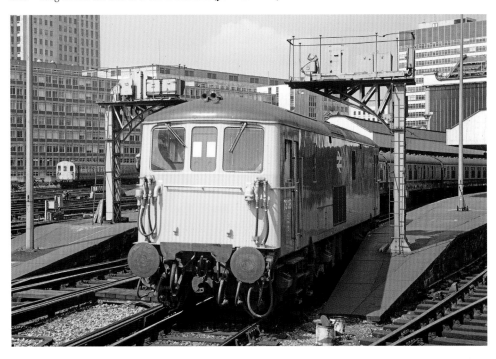

By the time No. 73138 was backing into Waterloo station on 9 August 1975, Typically Tropical had found fame with their hit 'Barbados' with just one week at number one. (Roger Bradley)

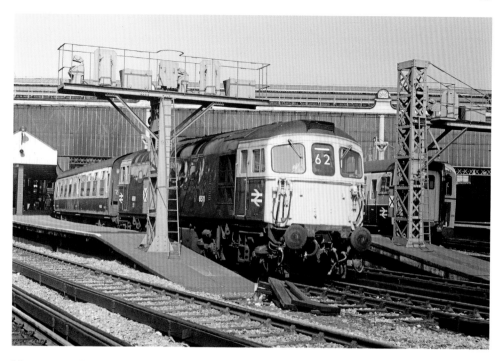

Motive power for the non-electrified lines beyond Basingstoke on the Salisbury route provided work for Class 33 No. 6511 on 25 August 1973 as the Crompton gets away from Waterloo on this 84-mile journey into Wiltshire. (Roger Bradley)

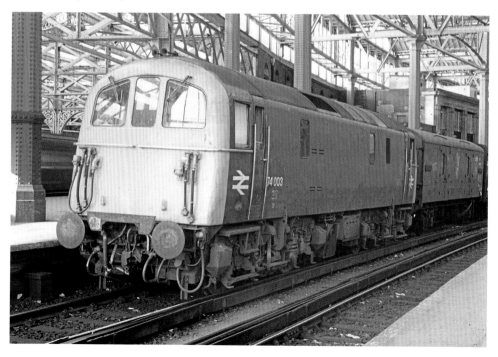

A slow shutter speed is required to record No. 74003 under the overall roof at Waterloo during its last few months of service on 13 September 1977. (Nev Sloper)

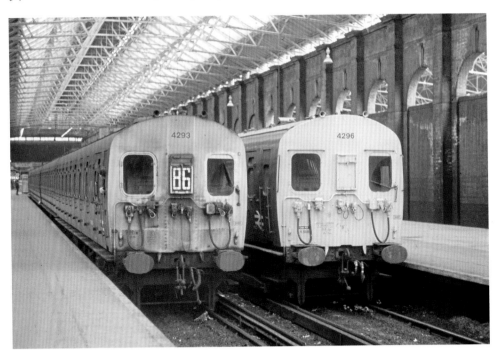

Underneath the overall roof at Victoria on the Central side with the motorman from 4-SUB No. 4293 looking back for the guards signal with a departure for Horsham via Mitcham Junction on 2 April 1978. (Ian James)

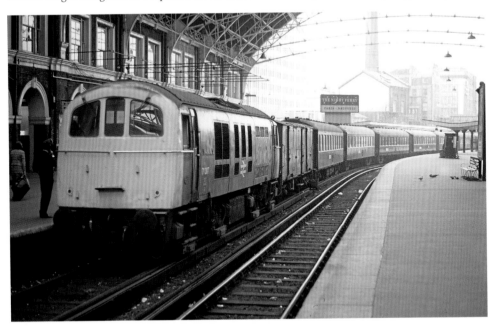

A heavy rake of Wagons-Lits coaches stands behind No. 71007 off *The Night Ferry* on arrival at Victoria in April 1974. *The Night Ferry* was Britain's first international passenger train, it commenced on the evening of 14 October 1936 and offered an overnight sleeping car service between London and Paris and eventually from 1956, to Brussels. The service was of course suspended during the period of hostilities, the final *Night Ferry* ran on 31 October 1980. (Strathwood Library Collection)

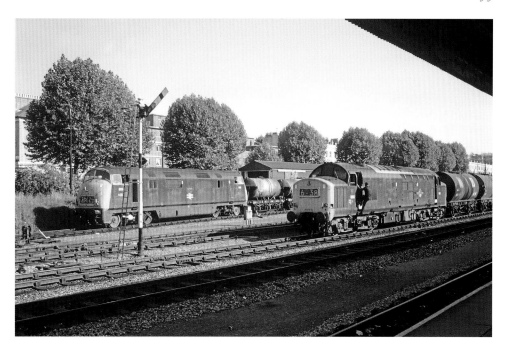

Although Kensington Olympia had been struck several times during the Second World War, particularly during the Blitz of 1940 and later by a flying bomb on 30 June 1944, things were a little more peaceful by September 1971 when Class 42 Warship No. 829 *Magpie* was engaged on milk tanks and Class 37 No. 6961 had arrived on a fuel tank working. (Ian Lewis/Strathwood Library Collection)

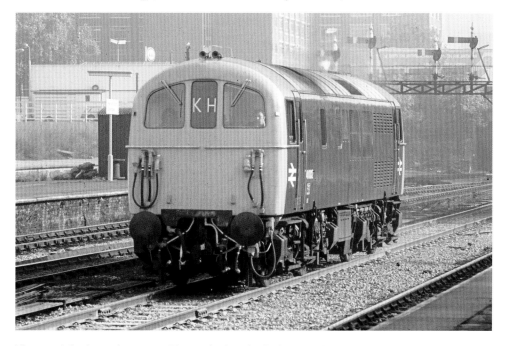

The erstwhile electric locomotive E5016 rebuilt to finally become No. 74002 runs through light engine at Olympia on 28 October 1975. Ironically these tracks had once been electrified by the LMS for their services from Willesden Junction before the war. (Aldo Delicata)

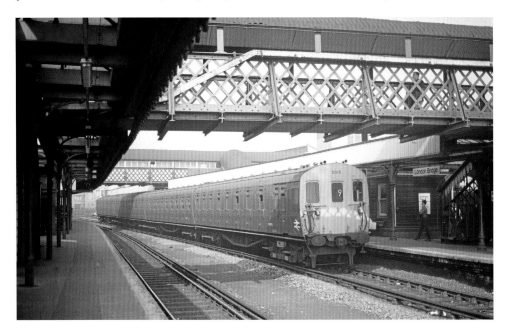

A Cannon Street to Bromley North train arrives at London Bridge with 4-EPB No. 5015 on 2 October 1971. This unit had entered service in 1952 and became Class 415 later in its career with a refurbishment programme at the start of the eighties to bring a longer service life to what were becoming very tired rolling stock. (Frank Hornby)

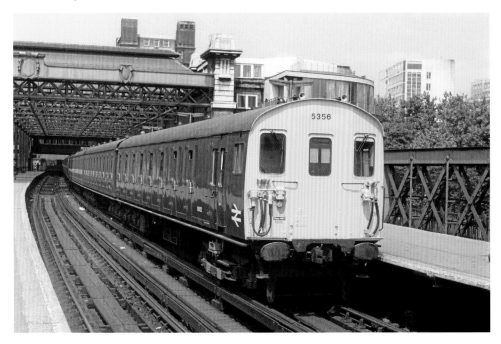

The later build of 4-EPBs for the Southern Region differed in many aspects as witnessed by No. 5356 which has worked into Charing Cross on 3 June 1978. Formula One racing this season was dominated by the distinctive John Player Special black and gold cars powered by Ford and driven by Mario Andretti and Ronnie Peterson. (Ian James)

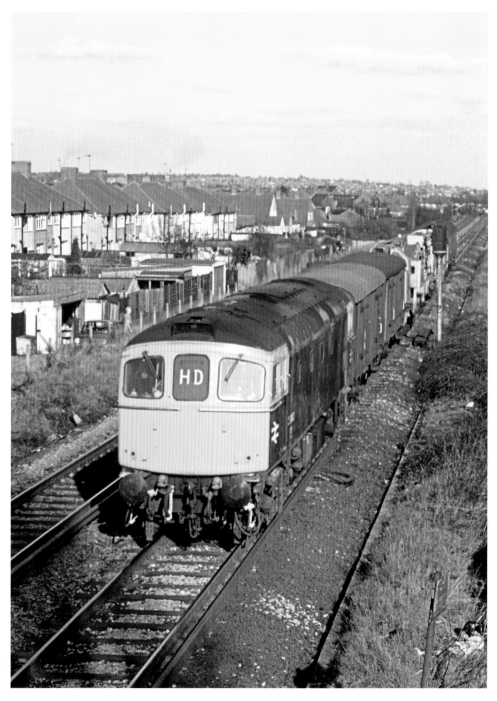

With such an intensive commuter service over much of the suburban network, the Southern Region was forced to lay on a great number of permanent way specials most weekends, such as this one headed by No. 33047 at Welling on Sunday 5 March 1978 working from Crayford Creek Junction to Hither Green. All across the region and most of the country many of the youth of the day were gripped by the Punk phenomenon and the Sex Pistols were at the forefront of this wave of raw energy that swept the nation in a similar way to how the Teddy Boys had disturbed suburbia at the end of the fifties. (Colin Whitbread)

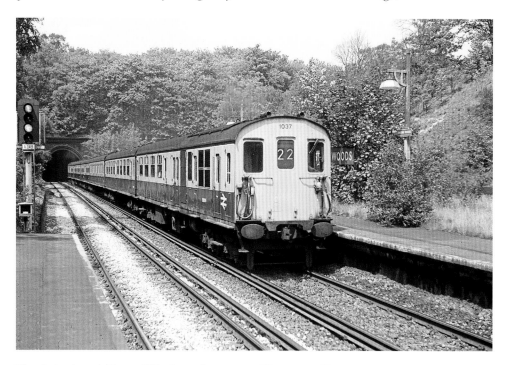

Thundering through Elmstead Woods on 9 June 1976 was Hastings unit No. 1037 at the head of the 12.45 Charing Cross to Hastings. With so many stations to change, the Southern Region had yet to get around to removing the old-style station signs and totems now so much beloved by collectors of railwayana. (Colin Whitbread)

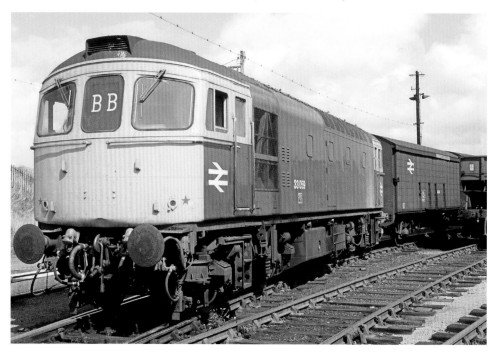

Ready to depart with a cross London freight on 25 August 1977 was Hither Green allocated No. 33059 which will head the 15.18 goods to Willesden from Plumstead. (Colin Whitbread)

Another Sunday engineering occupation at Eltham Well Hall on 3 April 1977 with one of the Hastings line gauged Class 33/2s, No. 33205 in attendance. The popularity of Fords at the time shows with an Anglia, Cortina and a Ford lorry the other side of the railway bridge. (Colin Whitbread)

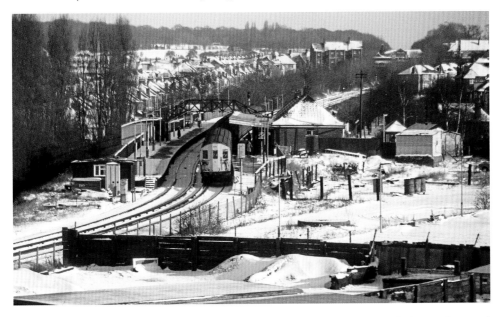

New Year's Day 1979 is greeted with snow at Eltham Well Hall and 4-EPB No. 5168 heads the 11.25 Gravesend to Charing Cross. This location hit the news on the evening of 11 June 1972 when the drunken train driver, in charge of an excursion from Margate returning to Kentish Town, failed to observe the 20-mph speed restriction for the curves here with his Class 47 running at around 65 mph. The resultant crash killed the driver and five passengers, injuring 126 others in an incident that shocked the nation as the dead driver was examined and found to be more than three times over the legal driving limit for a car. (Colin Whitbread)

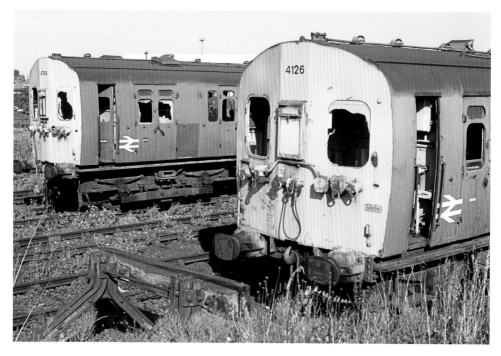

With so many units to dispose of during the seventies Selhurst was often used for storage for those awaiting their call to the breakers. In the yard on 18 September 1978 were 4-SUBs Nos 4748 and 4126. The attentions of local vandals had already been bestowed upon these once faithful units. (Colin Whitbread)

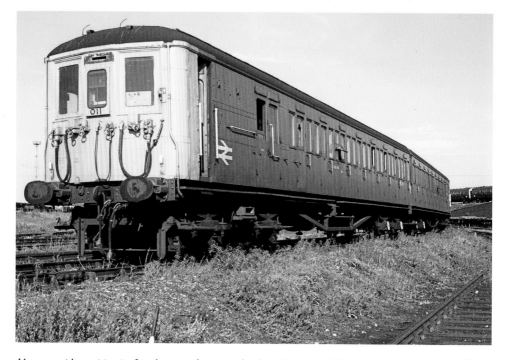

Also cast aside awaiting its fate the same day was redundant de-icing unit No. 011, one of ten which had been converted from pre-war 3-SUB coaches during 1959 and 1960. (Colin Whitbread)

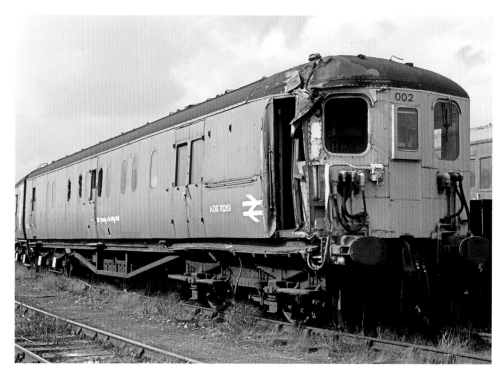

With the use of withdrawn motor coaches from 2-HALs, three de-icing units were formed in the late sixties, including No. 002, which appears to have been rough shunted during its period of storage when also seen at Selhurst, this time on 20 March 1979. (Colin Whitbread)

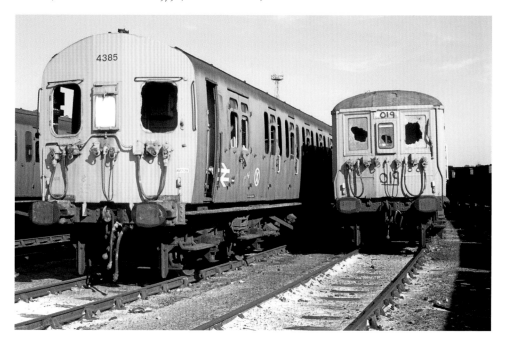

A final sad pairing of withdrawn 4-SUB No. 4385 and de-icing set No. 019 in the lines of vandalised stock at Selhurst on 18 September 1978. (Colin Whitbread)

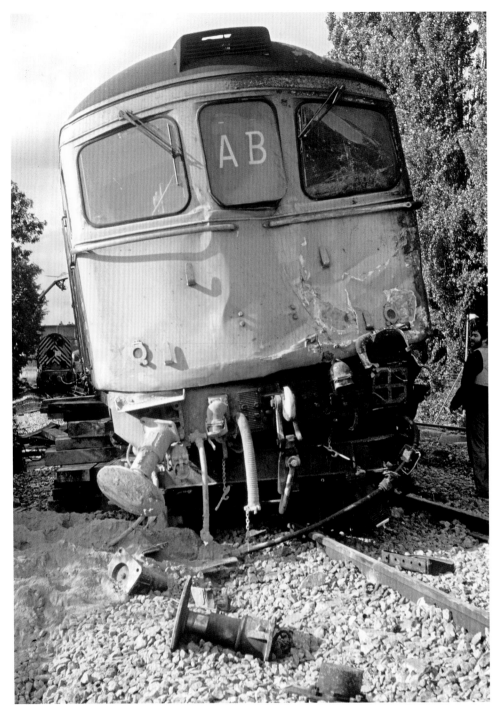

Damage of a different nature for No. 33043 stranded in the ballast at Mottingham on 11 October 1977. The unfortunate Class 33 was involved in a collision with No. 33036, which ended up rolling down the embankment into the back garden of a local resident. The pictured Crompton was repaired again but No. 33036 after recovery was deemed beyond saving when assessed at Selhurst and cut up there in October 1979, two years after the actual crash. (Colin Whitbread)

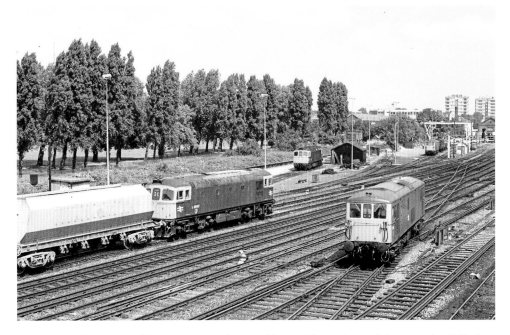

Passing stabled locomotives Nos 33012, 73131 and 73115 at Norwood Junction on 17 July 1979 with a Salfords to Cliffe freight working was No. 33037. (Colin Whitbread)

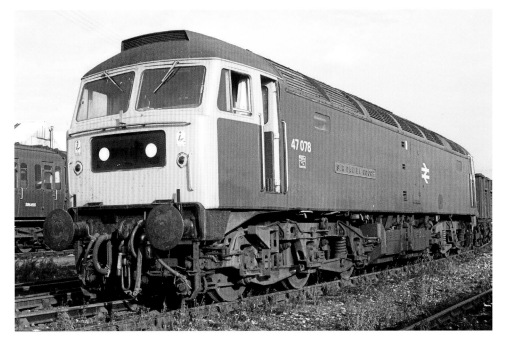

Catching the sun in Norwood Yard on 2 November 1978 was No. 47078 *Sir Daniel Gooch*; this Class 47 had been named two months after entering service as D1663 in a ceremony at Paddington in May 1965. It would carry these nameplates until early 1985 when after a brief period of running nameless it joined a selected few locomotives to commemorate GW150 with shiny new plates cast in brass to a traditional Great Western style. (Colin Whitbread)

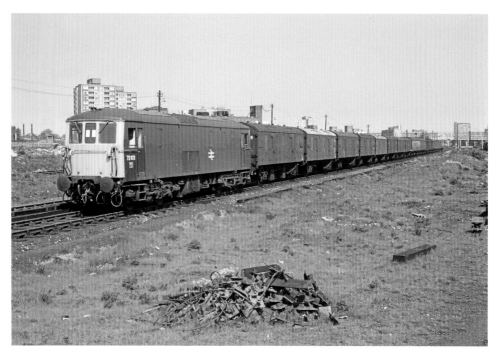

A long rake of vans makes up the 09.57 Margate to Bricklayers Arms close to its destination, headed by No. 73103 on 18 March 1977. There had been a major engine shed here, coded 73B, until 18 June 1962 when it was closed completely. (Colin Whitbread)

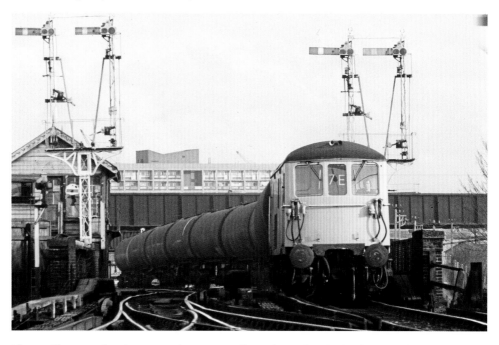

This would remain a busy location in the junctions of lines close to London Bridge long after the shed closed for the passage of freight trains, such as No. 73115 heading tanks from Hoo Junction to Salfords, passing Bricklayers Arms on 24 January 1977. (Colin Whitbread)

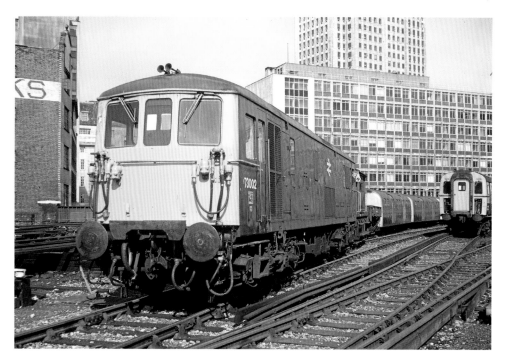

Not many spotters would have witnessed the movement of Waterloo and City line stock from their underworld existence onto the surface at Waterloo, caught here being marshalled behind No. 73002 in the North Sidings on 6 April 1978. (Strathwood Library Collection)

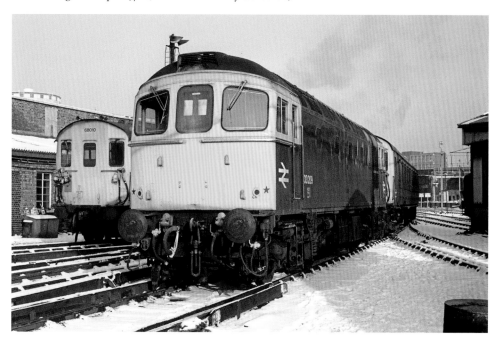

Shuffling around after a light snow fall on 24 January 1979 within the yard at Stewarts Lane was Hastings-gauged No. 33209 shunting a pair of the motor luggage vans used on the Folkestone boat trains. (Colin Whitbread)

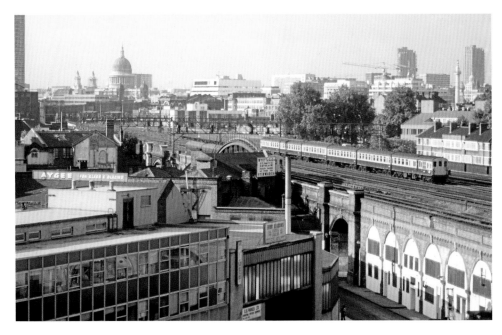

The London skyline would evolve beyond the few buildings seen here as Hastings DEMU No. 1013 gets away through London Bridge with the 15.45 Charing Cross to Hastings on the afternoon of 5 October 1979. Across the streets of the capital news stands would be still selling two evening newspapers for a few months more as the end of the decade approached, although 1980 saw the demise of *The Evening News*, leaving *The Evening Standard* to carry on alone after ninety-nine years of reporting to Londoners the latest news for their journey home on packed commuter trains. (Colin Whitbread)

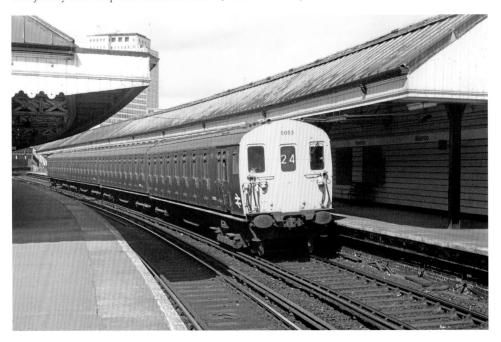

During the off-peak a single 4-EPB No. 5053 suffices for a Charing Cross to Hayes service at Waterloo East in July 1974. (John Dawson)

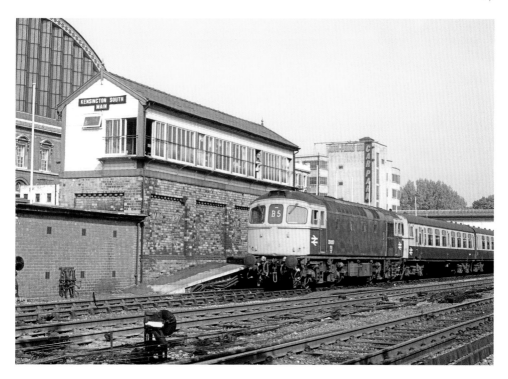

The signalman enjoys the sun while watching the progress of the ECS off *The Kenny Belle* headed by No. 33057 with 4-TC 424 on 31 May 1978 at Kensington Olympia. (Colin Whitbread)

A 4-CIG No. 7420 races alongside No. 33030 heading the 09.00 Waterloo to Exeter St Davids through Vauxhall on 2 May 1979. (Colin Whitbread)

Engaged in working a tanker train at Staines in October 1970 Class 73 E6034 is still over three years away from being renumbered as No. 73127. At this time a large number of local yards remained open or available to store wagons not in use on the Windsor lines. (Strathwood Library Collection)

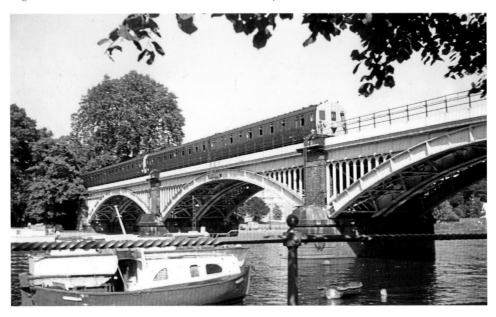

Two years later on 19 July 1972 a rake of 2-EPBs crosses the Thames on Richmond Railway Bridge. After the railway arrived at Richmond in 1846, the line was extended to Windsor and the Joseph Locke-designed cast iron bridge was opened in 1848. Due to concerns over its structural integrity, the bridge was rebuilt using the existing piers and abutments at the beginning of the twentieth century to a design by the London and South Western Railway's Chief Engineer, J. W. Jacomb-Hood. It reopened to traffic again in 1908 – the new bridge being very similar in appearance to the old one. (John Green)

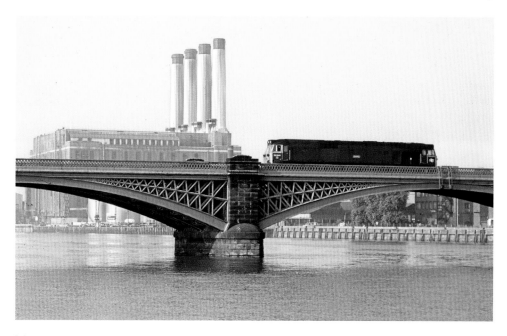

Making its way light engine on the morning of 27 August 1978 from Old Oak Common to Victoria was No. 50044 *Exeter* to work the first leg of The Vulcan Voyager Railtour, crossing the Thames on one of many bridges on this reach. This one was designed by William Baker, Chief Engineer of the London and North Western Railway, and was opened in March 1863, known as Chelsea Bridge to those associated with the railway, it is properly called The Cremorne Bridge. (Colin Whitbread)

Bright sunshine on 24 January 1978 as No. 33016 stands alongside a relic from the steam age with a water crane in the North Sidings at Waterloo on the Windsor side. (Strathwood Library Collection)

A sharp frost hangs on the rails at Willesden as No. 33053 awaits departure with the 09.15 Willesden to Sheerness on 30 November 1978. (Colin Whitbread)

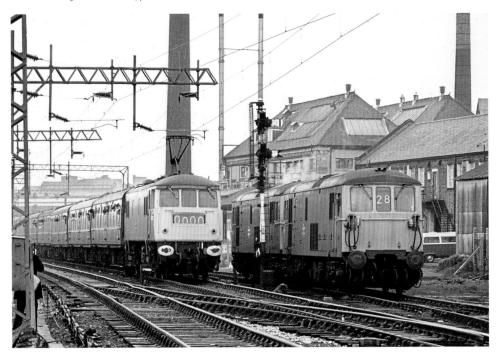

Changeover from electric traction on 31 March 1979 in the shape of No. 84002 which has brought The Wirral Wealdsman Railtour from Liverpool Lime Street bound for Ashford in Kent. At Mitre Bridge Junction Nos 73127 and 73104 wait to take the train onto the Southern Region. (Colin Whitbread)

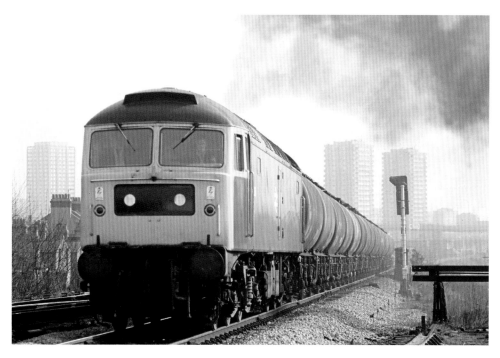

Notching up at North Pole Junction on 4 March 1976 is No. 47006 as the crew keep their train moving on the gradient here. (Aldo Delicata)

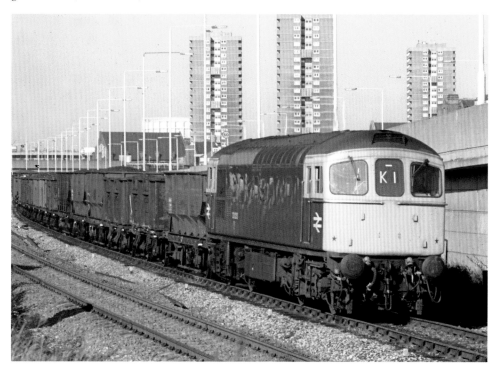

Much cross London traffic took the West London Line through Shepherds Bush during the decade as witnessed by No. 33033 with a coal working on 29 October 1978. (Aldo Delicata)

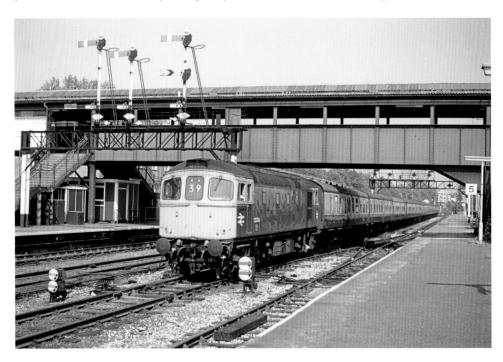

It was not only freight trains using this route as another Class 33, No. 33034, brings the 07.50 Wolverhampton to Ramsgate into Kensington Olympia on 31 May 1978. (Colin Whitbread)

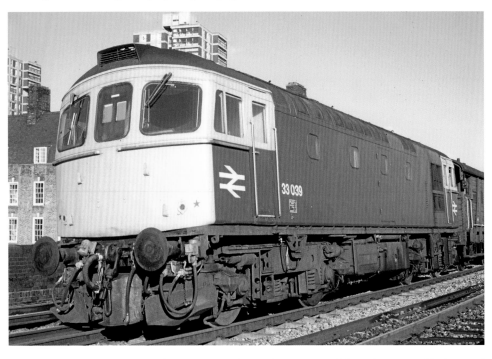

Ready to battle any light snow drifts that may build up is No. 33039 on 6 November 1979 at Elephant and Castle. A few months later and Bill Beaumont would lead the England rugby team to its first Grand Slam for twenty-three years. (Colin Whitbread)

In 1961, with the Kent Coast electrification scheme completed, the Golden Arrow became electric-hauled and was booked for a Class 71. A decline in demand for rail travel between London and Paris would see the last Golden Arrow run on 30 September 1972. Just before the end our photographer visited Victoria to record the scene for posterity. (Bob Treacher/Alton Model Centre)

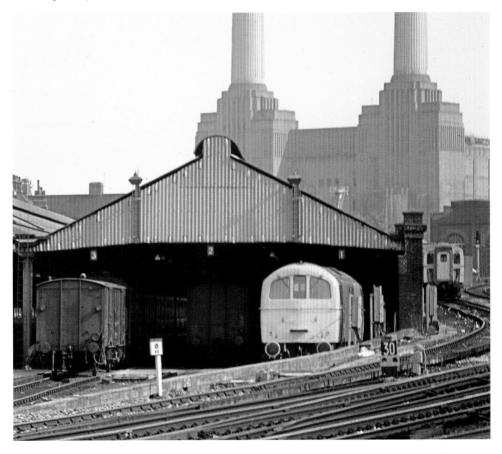

The stock for *The Night Ferry* was serviced during the day in the carriage sheds close to Grosvenor Bridge just outside Victoria station where a Class 71 waits in attendance on 17 May 1974. (Ian James)

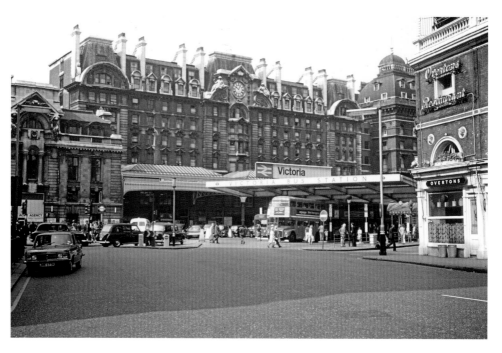

The distinctive frontage of Victoria station with The Grosvenor Hotel and the London Transport bus stands as it was on 14 May 1974. The station, when opened in 1860, was operated by four pre-grouping railway companies, The London Brighton and South Coast Railway, The London Chatham and Dover Railway, The Great Western Railway and The London & North Western Railway. The Great Western Railway remained a part owner until 1932, although their trains had long since ceased to use the station in Southern Railway days. (Frank Hornby)

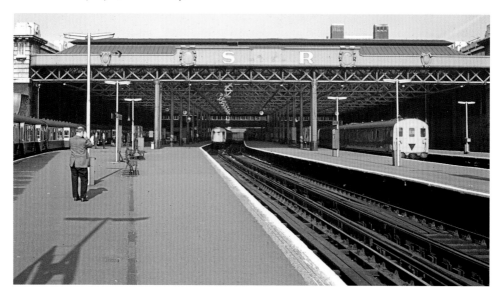

The South Eastern Railway established their London terminus at Charing Cross in 1864. The roof structure was rebuilt after collapse in 1905 and then again after the Second World War to repair bomb damage. In 1990 the station was rebuilt once more with a new building incorporated completely over the station in this photograph taken on 23 September 1972. (Derek Whitnell)

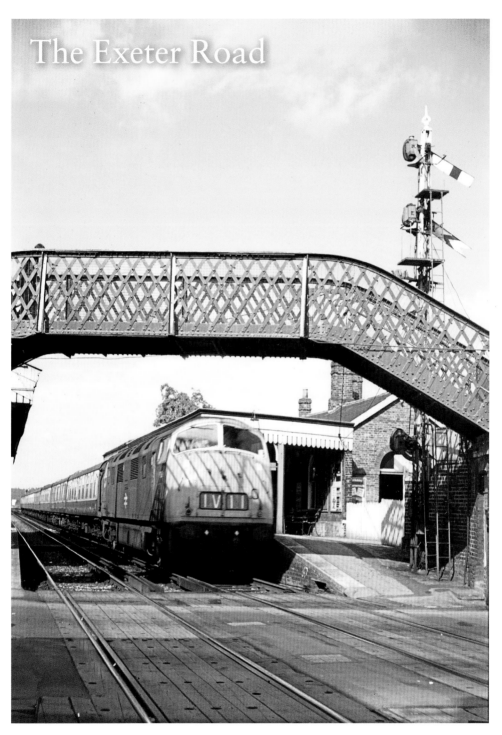

The Exeter Road

Many Waterloo to Exeter trains would be diverted off the main line via Virginia Water and onto the Windsor lines to reduce line occupation on Sundays, when engineering works dictated. One such Sunday in 1970 saw Swindon-built Warship D816 *Eclipse* thunder through Addlestone underneath the footbridge and across the level crossing in charge of a Waterloo to Exeter St Davids working. (John Green)

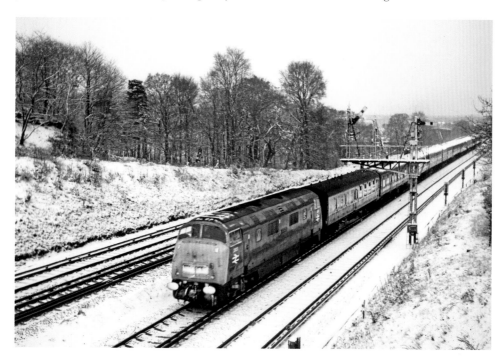

Another day after snow has fallen in early 1970 finds Class 42 Warship D820 *Grenville* running well behind time on the mainline near Weybridge with another Exeter service. (John Green)

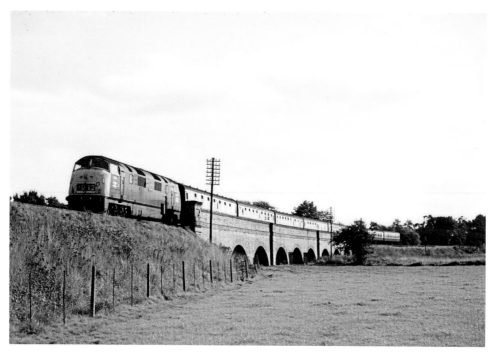

Again to be faced with a Sunday line occupation on the main line in 1970 was D826 *Jupiter*. This Exeter to Waterloo train will also be pushed to arrive right time in London, although no doubt the driver of the Warship will use all of his steed's 2,200hp where he can. (John Green)

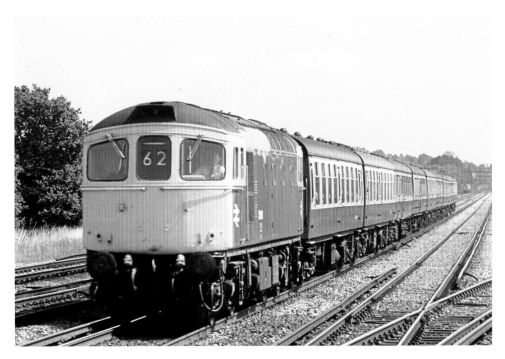

Running fast through Byfleet on 26 July 1975, No. 33021 has a smartly attired driver with his tie adjusted correctly, even though it is a hot summer's day, to make his journey with a Salisbury semi-fast. (Aldo Delicata)

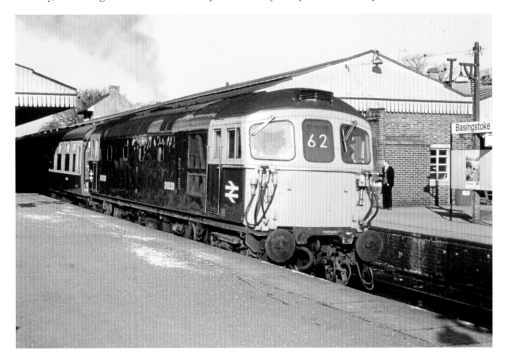

Another Salisbury semi fast has arrived at Basingstoke behind Class 33/1 D6520 around 1970. The 36 miles between these two stops had, at the beginning of the sixties, eight stations open for traffic, half of which would be closed by the beginning of our decade. (Strathwood Library Collection)

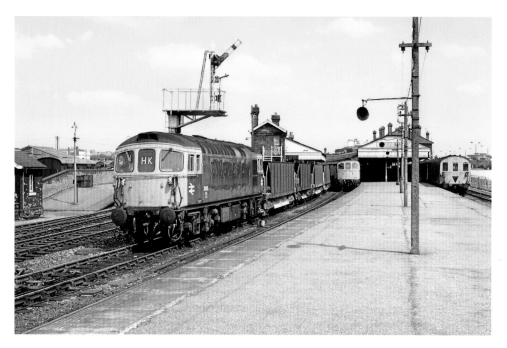

A busy moment at Salisbury in July 1976 as No. 33115 makes its way through the station, which is subject to a severe speed restriction due to the curvature of the track, and the infamous accident in 1906 when a Plymouth to Waterloo express took the 30-mph curves at 70 mph. The resultant derailment brought about the deaths of twenty-eight people. (Arthur Wilson)

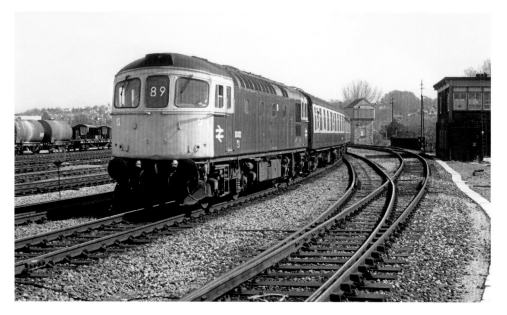

Arriving past the once busy yards at the east end of Salisbury station is the former D6550 now running as No. 33032. This Crompton was released to traffic from the Birmingham Railway Carriage & Wagon Company's works in Smethwick in early April 1961. Fifteen years later it had made six moves between Hither Green and Eastleigh depots as they kept moving the engine from one to the other every few years. (Strathwood Library Collection)

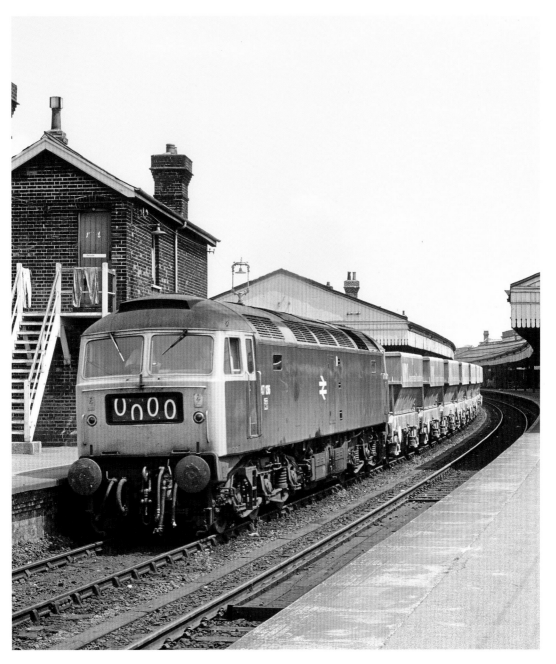

Bristol Bath Road has provided No. 47136 for this aggregates turn running through Salisbury on a very warm day in July 1976. Among the hot albums selling as LPs, music cassettes or eight-track cartridges that summer were; *Wings at the Speed of Sound*, Eagles – *Their Greatest Hits 1971-1975* and *Frampton Comes Alive*. 1976 is most remembered for the great drought, that summer was one of the best summers ever in the UK. London had a record June temperature of 95°F (we thought in Fahrenheit then!). We had a heatwave that went on for weeks and weeks. Many will remember the ground cracking and the tar on the road melting. In some areas people had their water supply turned off for most of the day to conserve water. Hosepipe bans were across the country and even firemen in the New Forest were told not to put out forest fires. (Arthur Wilson)

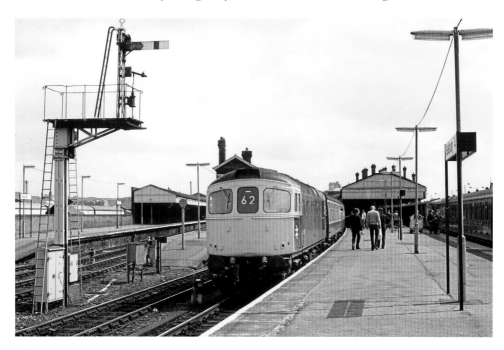

The peace of Salisbury station is interrupted for a few minutes as the Sulzer engine of No. 33017 ticks over while awaiting to depart west with the 11.00 Waterloo to Exeter St Davids. While across the platform a pair of Thumpers add to the mix with their distinctive English Electric staccato, all of this would be intermingled on 20 August 1979 by the clatter of doors slamming. (Colin Whitbread)

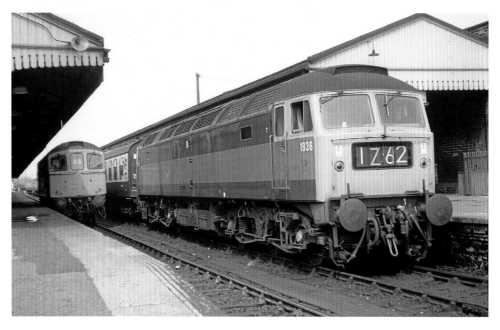

A two-tone green No. 1936 has just pulled into Salisbury working an unknown excursion in 1970. This Class 47 would be among the last of the class to be repainted into blue, gaining the application of a new TOPS number, No. 47494, for eleven months whilst still in green before a long-overdue makeover. (Strathwood Library Collection)

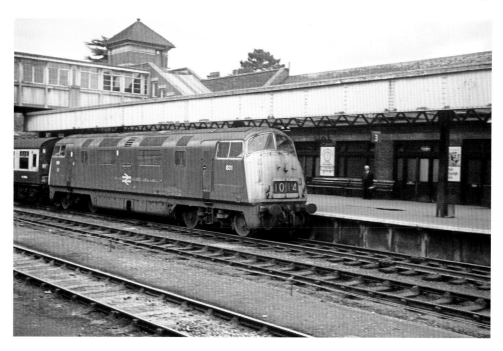

By the time most of the Warships were being taken out of service their external condition was becoming a concern. Among these scruffy examples in their last days was Class 42, No. 831 *Monarch*, which was looking less than regal as it pulled into Exeter Central in May 1971 with just four more months to go in service before heading to Swindon for scrapping. (Strathwood Library Collection)

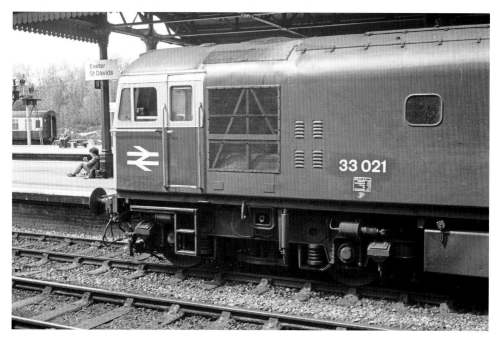

Standards of cleanliness were not being kept up in June 1979 either, as witnessed by No. 33021 on arrival at Exeter St Davids while two spotters appear un-moved by the Crompton, which would have been a regular to their notebooks back then. (David T. Williams)

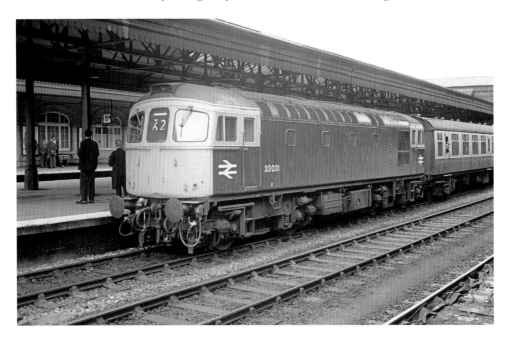

More indifference for No. 33031 as it ticks over in May 1979 at Exeter St Davids almost 174 miles from Waterloo. Certainly getting noticed earlier in the year was the death of Sex Pistols' bass player Sid Vicious; he died of a heroin overdose in New York. His mother found him dead in bed with his sleeping girlfriend in an apartment in Greenwich Village in February. The previous night there had been a party in the flat to celebrate his release on $50,000 bail pending his trial for the murder of his former girlfriend, Nancy Spungen, the previous October. (David T. Williams)

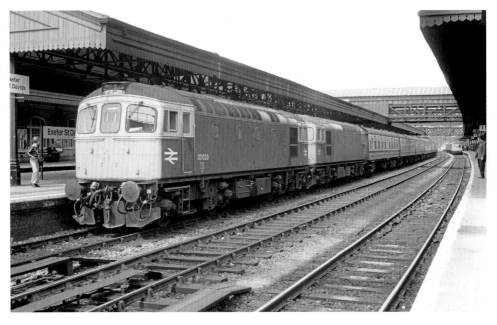

However if a pair of Cromptons come into view, such as Nos 33035 and 33037, again on the same day at Exeter St Davids, they do more to attract the attention from a couple of spotters on the platforms. (David T. Williams)

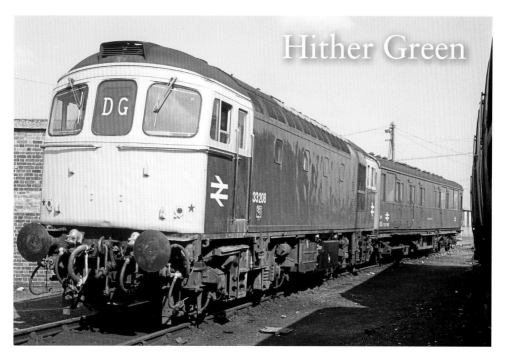

Coupled to TDS 70155 one of the special Hastings-gauged route inspection coaches is one of the slim line Cromptons No. 33205 ready for a trip out on the mainline on 17 April 1978. (Colin Whitbread)

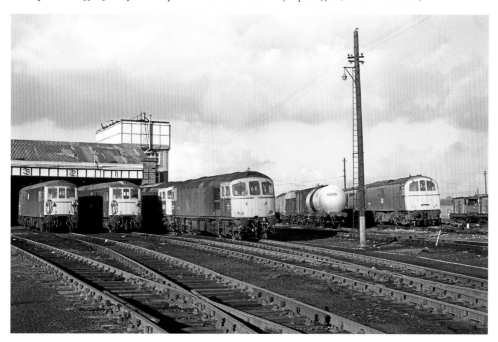

The line up on a quiet Sunday on 20 November 1977 includes Nos 73005, 73120, 33033, 33050 and 71004. Withdrawn or stored Class 71s would be a fixture for a number of years on the scrap line, as we will see in the next few pages. A number of the depot's locomotives would be out perhaps on permanent way duties, so any spotters visiting may miss out on that engine they were chasing. (Colin Whitbread)

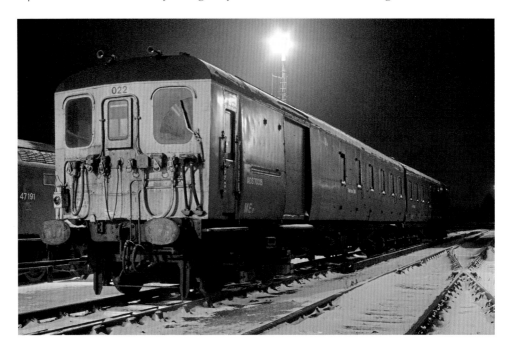

No, not a de-icing unit visiting to help deal with the snowfall on Friday evening 16 February 1979, but No. 022 is one of the stores units we had seen first of all on page 19 at Clapham Junction five years earlier. (Colin Whitbread)

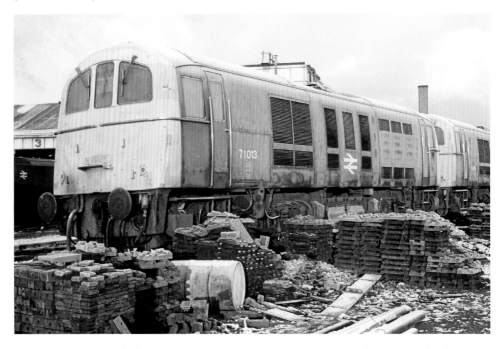

Set aside as stored in early October 1976 was No. 71013, as the sun came up on the morning of 29 December 1976 a hoar frost had developed tempting our cameraman into recording the Class 71. More frost would form on this locomotive before it would finally depart from Hither Green in mid-June 1979 almost three years after it was first parked up here. (Colin Whitbread)

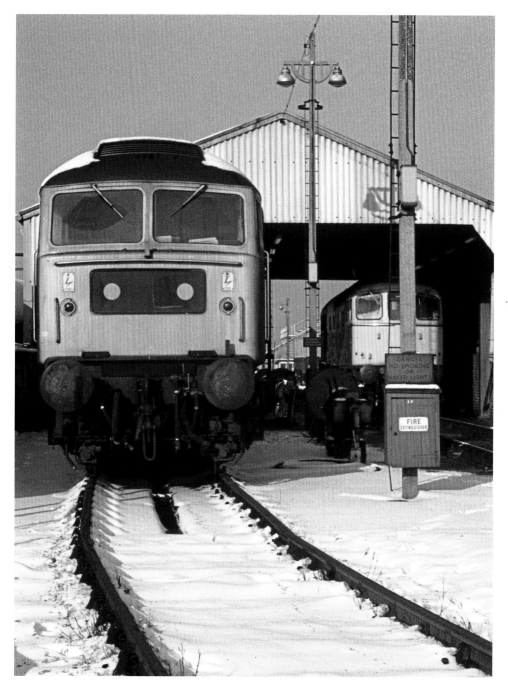

Morning sun and snow greets our arrival on 24 January 1979 where Nos 47256 and 33209 have been stabled over a cold night by the refuelling point. Until the seventies, most people in the UK made up beds with sheets and blankets. In the early seventies the bedroom revolution was the continental quilt or duvet. Names such as 'Slumberland Fjord' and 'Banlite Continental' left no doubt as to the origin. Mostly they were filled with down or duck feathers. Synthetic fillings were more common in Europe, but later became available in the UK. People quickly took to them as they were more convenient, it should also be remembered that many homes were yet to be fitted with central heating. (Colin Whitbread)

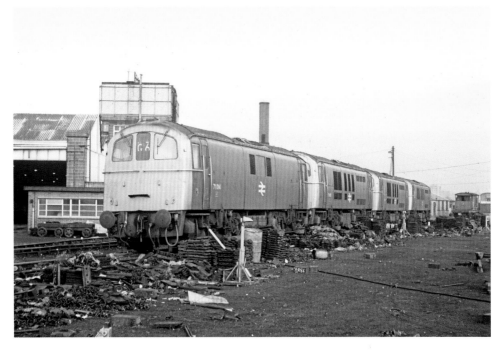

Leading the line of doomed Class 71s on 10 October 1976 was No. 71014 along with Nos 71004, 71009 and 71013 adding to the general depot clutter. (Nev Sloper)

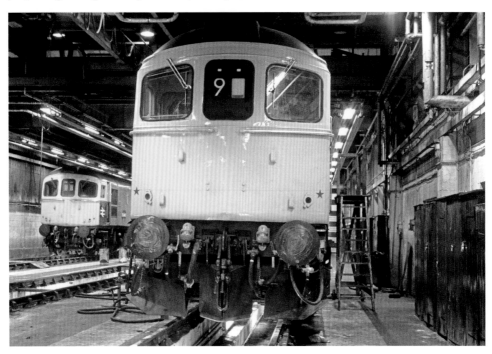

Maintenance standards inside the shed building were very high with Slim Jim No. 33202 gaining a depot repaint while fellow Type 3 No. 33009 watches on, all in a very tidy working atmosphere on 22 March 1979. (Colin Whitbread)

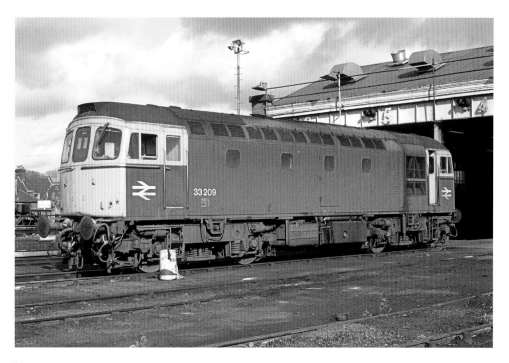

The external cleanliness of another of the Class 33/2s, No. 33209, is less favourable standing outside in the spring sunshine on 24 May 1979. (Colin Whitbread)

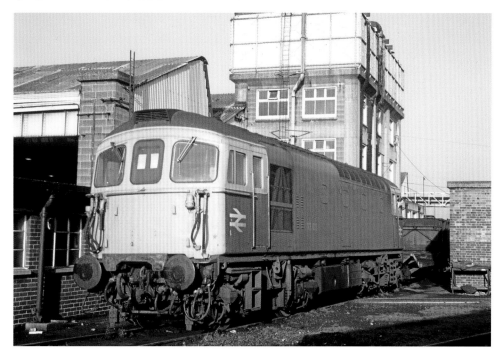

Further evidence of hard work can be found along the flanks of push-pull fitted No. 33103 on 1 November 1977 while stopped at the depot. This variety of Crompton tended to be less common on the Eastern Section as they did not run any of the TC units which were largely confined to the Western Section. (Colin Whitbread)

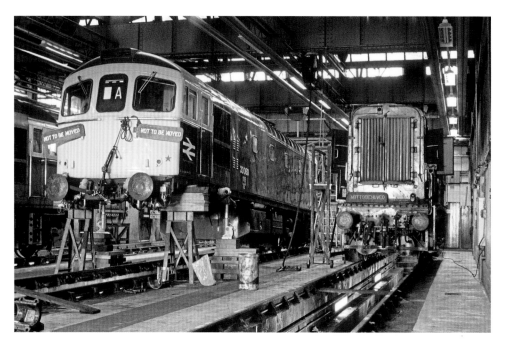

For those spotters visiting the depot they might venture inside the shed first before wandering around the yard. On view on 8 March 1979 were No. 33060 along with No. 08760 receiving the attentions of the fitting staff. (Colin Whitbread)

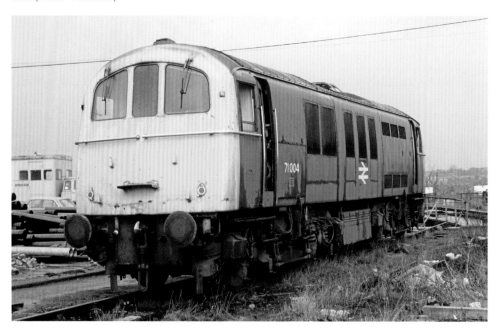

The records show that this Class 71 was never allocated to Hither Green although it spent so long dumped here. When new it was based at 73A Stewarts Lane in June 1960, then as 75D two years later when the shed code was changed, then finally to 73F Ashford in August 1966 remaining here to the end after the code changed to AF. When this view was taken on 8 April 1979 it was weeks away from the move north to Yorkshire and the torches. (Aldo Delicata)

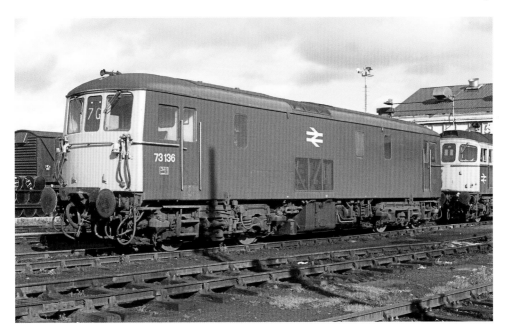

When No. 73136 was being built at The Vulcan Foundry in 1966 it was alongside a number of Class 20s that were still coming off their production lines. All of the second production batch of Class 73/1s would enter service in the then new blue livery, albeit with half-yellow fronts and white windscreen surrounds. This example as E6043 went new to Stewarts Lane and would remain based there right through the seventies, adopting this new TOPS number in February 1974. (Colin Whitbread)

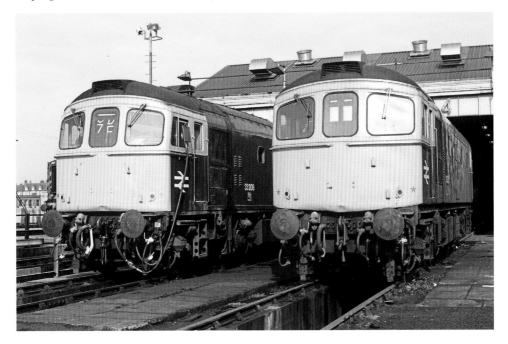

A chance to compare profiles of the last twelve of the Cromptons delivered in the early months of 1962 to the narrower loading gauge against the main production batch on April Fools day 1979 with Nos 33208 and 33055 on the inspection pits outside the shed building. (Colin Whitbread)

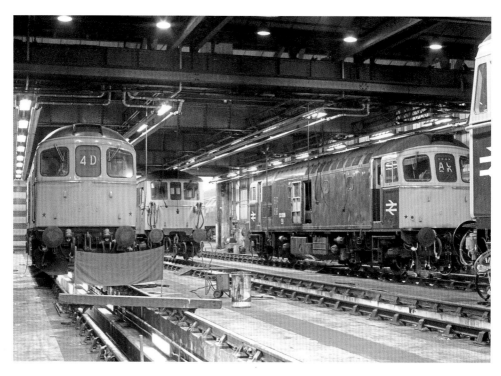

Another view on the same day now finds No. 33208 inside the depot in company with Nos 33206, 73127 and 33043; again high standards of maintenance appear to be the order of the day. (Colin Whitbread)

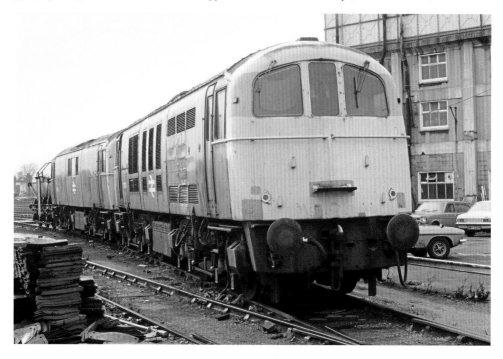

By 8 April 1979 this pair of Class 71s, Nos 71014 and 71013, made a pretty sorry sight alongside the depot's car park with a Capri, Escort and new Cavalier visible, all very seventies. (Aldo Delicata)

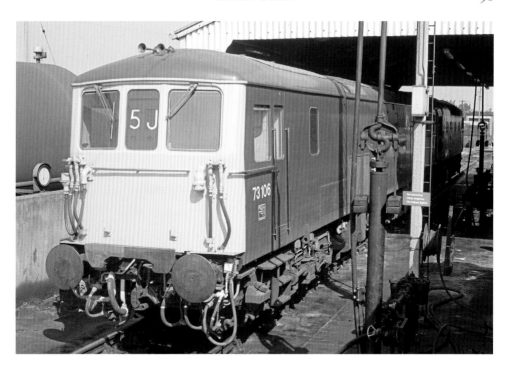

Taking on diesel fuel on 4 June 1977 was No. 73106, capacity when full for the Class 73 would be 340 gallons. One sobering thought against today's world is that during the week after this shot was taken the Apple II, the worlds first practical personal computer, went on sale. (Colin Whitbread)

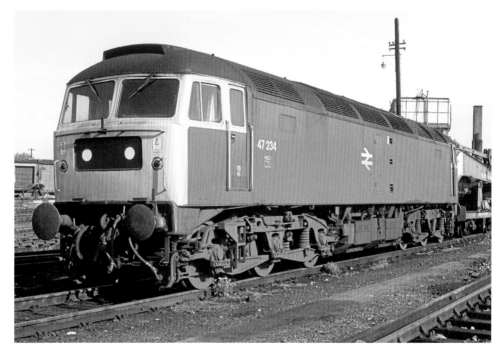

Class 47s had often been frequent visitors to the depot at Hither Green since the late sixties for servicing, so the visit of No. 47234 from Cardiff would not be unusual when photographed on 21 May 1979. (Colin Whitbread)

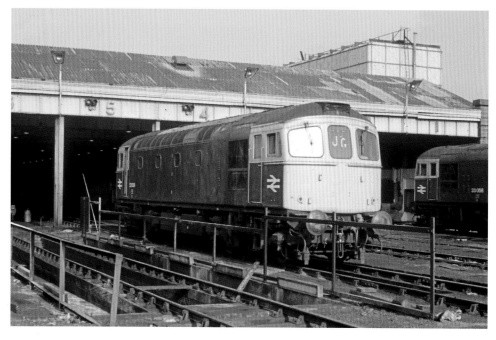

It was a leap year in 1976 and on shed that extra February day was No. 33054 in company with another classmate, no doubt several more of the region's workhorses would be recorded by our photographer that day in his notebook. It would also be the year that Clint Eastwood would practice with his mean looks in the film *The Outlaw Josey Wales*. (Nev Sloper)

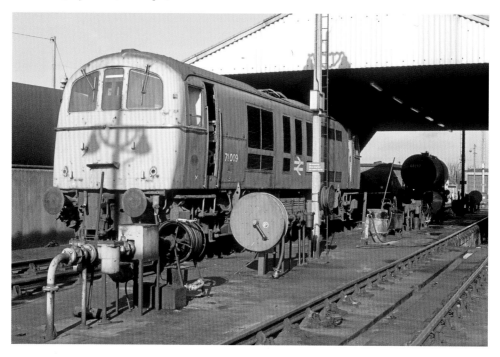

No it is not an early April fools joke of where do you refuel a Class 71 on 8 March 1979, but No. 71009 is being prepared to travel to the breakers after being stationary for over two years. (Colin Whitbread)

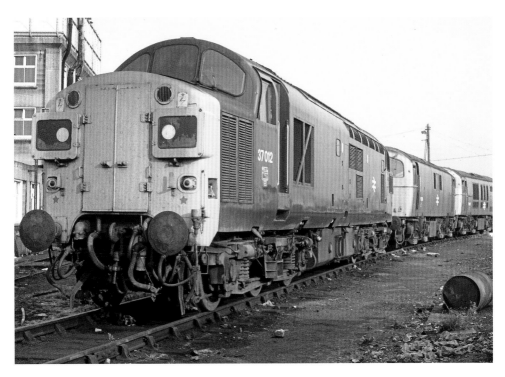

Having arrived in the area on a cross London freight, Stratford's Class 37, No. 37012, has been stabled by its crew close by our old friends and Nos 71014 and 71013 on 20 September 1978. (Colin Whitbread)

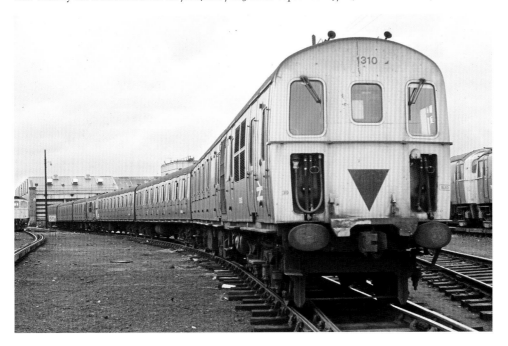

You really would have to work hard to keep out of the viewfinder those Class 71s during this period, as they creep in again as this pairing of 3D East Sussex units Nos 1310 and 1314 have stopped off on their way to Slade Green for overhaul on 10 March 1977. (Colin Whitbread)

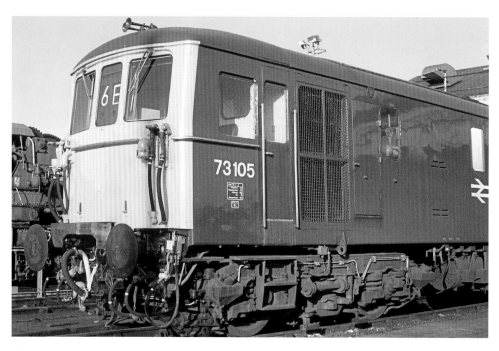

A recent visit to works is evident in this close up of No. 73105 which was visiting the depot between turns on 8 March 1979. If you were listening to the radio and looking for the weekly *Top Twenty Chart Show*, it was hosted by Simon Bates on Radio One, with music in the charts that has stood the test of time well, as a good number of radio stations across the country play many of the tracks of this time everyday – thirty years later. (Colin Whitbread)

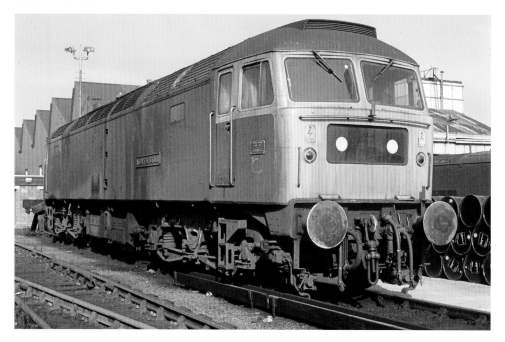

Another Western Region-named Class 47 deep into Southern territory with No. 47077 *North Star* again based at Cardiff at this time has found its way to Hither Green on 25 February 1979. (Colin Whitbread)

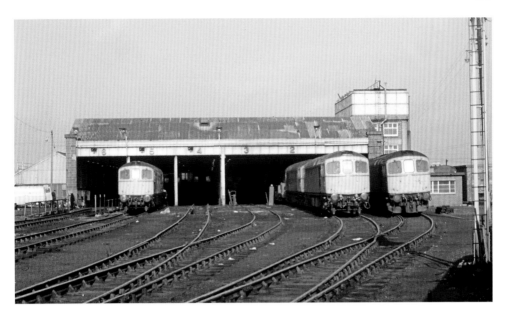

One last look back at the line up outside the depot in February 1976 before we make our way back along the footpath to the station, where on another visit on 10 October 1976, No. 33035 has pulled up with a train of concrete sleepers and a friendly Southern Region crew lean out for a chat. (Both photographs Nev Sloper)

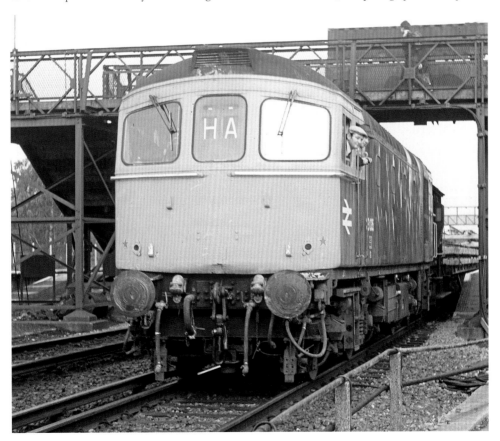